ANONYMITY *in* COLLABORATION

Also by [Ruiling Lu]…

Lu, R. (1993). *English Reading Comprehension Manual for Teacher Trainees.* Shanxi Higher Education Press, China.
Lu, R., & Shi, Z. (1998). *Self-Learning Guide to College English.* Chinese Jiliang Press, China.
Lu, R. & Jia, X. (2000, Ed.). *Collected Works on English Language Learning and Teaching.* Chinese Cultural Association Press, China.
Lu, R. & Wang, Y. (2006, Translation). *Formula 2+2: The Simple Solution for Successful Coaching* (Authors: Douglas Allen & Dwight Allen). China Machine Press, China.

ANONYMITY *in* COLLABORATION

Anonymous vs. Identifiable e-Peer Review in Writing Instruction

Ruiling Lu

1663 Liberty Drive
Bloomington, IN 47403

Order this book online at www.trafford.com
or email orders@trafford.com

Most Trafford titles are also available at major online book retailers.

Printed in the United States of America.

ISBN: 978-1-4269-8211-8 (sc)
ISBN: 978-1-4269-8212-5 (hc)
ISBN: 978-1-4269-8213-2 (e)

Library of Congress Control Number: 2011913735

Trafford rev. 08/09/2011

 www.trafford.com

North America & international
toll-free: 1 888 232 4444 (USA & Canada)
phone: 250 383 6864 ♦ fax: 812 355 4082

To my devoted parents

FOREWORD

I first met Ruiling Lu in Taiyuan, China, where she was an assistant professor at the Shanxi Institute of Education, in 1991. She was a bright, well-trained, excellent English language teacher. I told her on that first visit that I hoped she could come to the United States and study with me for her doctorate.

It was a few years later that it became possible for her to come to Old Dominion University. I was fortunate to have her as a Graduate Teaching and Research Assistant for six years, as she pursued her doctorate. Her focus was on language teaching and researching language teaching effectiveness. I taught two sections of Freshman English Composition as a service to the university, a course not favored by either professors or students. I wanted to see if I could teach the course in such a way that both they and I enjoyed the experience at the same time as their writing skills improved. Ruiling made several important suggestions for the improvement of the course and proposed to use a comparative analysis of the two sections for her dissertation research.

Peer review has become commonplace, but it is still used in ways that are sub-optimal. I have always been of the opinion that the best way to learn to write is to learn to write quickly and easily, with lots of feedback in near real time with the requirement to rewrite based on that feedback. In my classes students were required to write three drafts, the first reviewed by two or three peers with comments following an editing template. The student author was free to use or ignore the comments, but based on this feedback, produced a second draft which was then critiqued by the instructor. Again the student was free to take or ignore the comments of the instructor, and produced a third and final draft incorporating the critique as s/he wished.

The results were robust, with the average student improving both the speed and quality of writing, and equally important, reporting an improved attitude toward writing.

I felt very good about creating an environment where students gave and received critiques comfortably. But Dr. Lu felt that even more honest and useful critiques would be possible in an anonymous

environment, made possible by the online environment. And she was right.

She examined the relative effectiveness of personalized versus anonymous feedback in peer editing. Before on-line posting of written work was possible, anonymous feedback was impossible. Now it can be easily managed. She found, and this book details how anonymous feedback improved both the quality and the candor of peer feedback. Her study establishes some important new parameters for online instructional design.

Students in the anonymous e-peer review group outperformed their counterparts in the identifiable e-peer review group on writing performance and they provided more critical feedback (and lower ratings) on their peers' writing.

Her findings also confirmed the importance of close attention to the structure of the e-learning environment. The peer review system works only when students take responsibility for providing timely feedback. When feedback is not given, other peers suffer. Late work must be punished harshly, and the peer review efforts must be graded immediately – timely feedback on their feedback.

One of the weaknesses of distance education and mediated instruction of all kinds is that it is still in phase 1 of its development. Phase 1 is characterized by the new technology mimicking the old. Phase 2 is when the new technology finds ways to expand beyond the limits of the old technology. Dr. Lu suggests new options for e-learning, and confirms the rewards for doing so.

Dwight W. Allen
Aurora, Colorado, August, 2011

PREFACE

The content of this book was adapted from the author's dissertation study. The purpose of the study was to compare the effects of anonymous e-peer review with identifiable e-peer review on student writing performance and perceived learning satisfaction. It also investigated whether anonymous e-peer review facilitated a greater amount of critical peer feedback.

Quasi-experimental design was used to test group differences on the dependent variables. Participants were 48 freshmen enrolled in two English Composition classes at an American urban university. The two intact classes taught by the same instructor were randomly assigned to the anonymous e-peer review group and the identifiable e-peer review group.

The results of the experiment showed that students in the anonymous e-peer review group outperformed their counterparts in the identifiable e-peer review group on writing performance; students in the anonymous e-peer review group provided a greater amount of critical feedback and lower ratings on their peers' writing. No significant differences between the anonymous e-peer review group and the identifiable e-peer review group were found on student learning satisfaction.

ACKNOWLEDGMENTS

First and foremost, my immense gratitude to my dissertation committee, Dr. Dwight Allen, Dr. Linda Bol, and Dr. Charlene Fleener. To Dr. Allen, my advisor and committee chair, who started me on the journey and helped me stay on the course. His philosophy, insights, creativity, generosity, kindness, and encouragement were essential to my successful completion of this journey. I consider myself extremely fortunate to finish my doctoral study under his guidance. To Dr. Bol, who dedicated a great amount of time, energy, and ideas to this project. Without her guidance, expertise, stimulation, and support along the way, there would never be this product. To Dr. Fleener, who patiently reviewed and edited every word of this product. Her kindness, cooperativeness, understanding, and help are greatly appreciated. It was the best committee I could have hoped for, and I have benefited enormously from their collective efforts and accountability for their students.

I would like to extend a special thank to Dr. Carole Allen, who provided me with a plenitude of valuable advice both academically and personally. Her care, consideration, benevolence, and mentorship made my life in a foreign land so easy and agreeable.

Thanks to all the participants in the experiment, the instructor, the teaching assistant, and all the students. Their involvement and cooperation were a pivotal part of this research.

Appreciation is also extended to particular members of the faculty and staff of Darden College of Education, Dr. Overbaugh, Dr. Tonelson, Ms. Barbara Webb, Ms. Jan Becker Willcox, and Mr. Brian Hodson. Their consistent academic and administrative support helped make my learning and working experiences pleasant and manageable.

Credit goes to my husband, who brought me to the United States, and made this special educational opportunity available to me. To my dearest son, who accompanied me in all these years, and continually refilled me with joy, hope, and dreams. For him, I started the journey, and because of him, I stuck to the end.

Most importantly, I owe a debt of gratitude to my parents. I cannot express how much their ever-lasting love, concern, supports, sacrifice, and never-wavering confidence in me have meant to me in this journey and in my life. Whatever is good about me is because of them and belongs to them!

—Ruiling Lu

TABLE OF CONTENTS

LIST OF TABLES

LIST OF FIGURES

CHAPTER I

INTRODUCTION

Writing is recognized as a key factor in students' academic lives, and it is the primary means by which students transform from passive recipients of knowledge to active participants in their own education (Harvard's Expository Writing Program, 2002). Research on writing implies that writing promotes language development and knowledge construction, writing deepens understanding and enhances critical thinking, writing affords students an indispensable tool to record what they have learned and observed, writing improves students' organizational capabilities and promotes effective communication, and that writing nurtures thought; writing provides an intellectual foothold in college (Silva, Cary, & Thaiss, 1999; Richardson, 2001; Harvard's Expository Writing Program, 2002; Shaw, 2002; Lindblom-Ylanne &Pihlajamaki, 2003).

The importance of writing requires no elaboration, but the fact is that a large number of American students present inadequate writing skills. The results of the National Assessment of Educational Progress (National Center for Education Statistics, 1998) indicate that 16% of 4th-grade students, 16% of 8th-grade students, and 22% of 12th-grade students are not able to write at even the most basic level. On college and university campuses, more and more students come with inadequate proficiency in writing (Baker, Gersten, & Graham, 2003). Compared with other nations, the United States is lagging behind with respect to writing and literacy (Richardson, 2001). According to Isaacson and Howell, student writing problems surface early and tend to remain with students throughout their schooling experience, and they lead to the greatest number of referrals and placement in special and remedial education programs (as cited in Baker, et al.). Therefore, it is unarguable that training students with appropriate writing skills is one of the major tasks at all levels of education.

For the past 100 years, almost every college and university in America has had a first semester course in writing (Richardson, 2001). Instructors and researchers have been motivated by the core question of how best to teach writing. They have been exploring and

experimenting with various methods, trying to discover more effective ways to help students become better writers.

Studies on the use of peer reviews in writing instruction—students work together to provide feedback on one another's writing—began about 25 years ago (Ford, 1973). Nearly two decades later, peer review and/or peer edited drafts of papers have become a common approach in writing instruction at the college level throughout the United States (Mangelsdorf, 1992; Zhu, 1995; Eschenbach, 2001). It is reported that 82% of college writing instruction involves students in peer review process (Lynch and Golan, 1992). The use of students' evaluation of the writing efforts of their peers has become an important feature of most writing programs (Kerr, Park, & Domazlicky, 1995). In research community peer review is probably the most widely used approach when evaluating research (Asberg & Nulden).

Theoretical Foundation of Peer Review

Strong support for peer review has come from theories that emphasize the social nature of learning, language, thought, and writing (Zhu, 1995). According to social constructivism, learning "requires exchanging, sharing, and negotiation, as well as occasionally drawing on the expertise of more knowledgeable individuals", and learning "involves both personal inner process and social aspect" (Liu, Lin, Chiu, & Yuan, 2001, p.247). The Vygotskyan (1962, 1978) perspective on learning a language lends particularly strong support for the use of peer review, which allows student interaction and negotiation of meaning to take place during the writing process. For Vygotsky, learning is not an individual, secluded activity, but rather a cognitive activity that occurs in, and is mediated by, social interaction; therefore, social interaction is essential to learning. Thus, on the theoretical level, peer interaction is vital to writing development because it allows students to construct knowledge through social sharing and interaction (Liu, et al., 2001).

Peer review is also built on the notion of collaborativism, whose basic premise is that learning emerges through shared understandings of more than one learner, and whose goals are active participation and communication (Leidner & Jarvenpaa, 1995). Collaborativism assumes that the control of learning should rest with peer groups, and that

learning is the sharing of knowledge among learners (Asberg & Nulden). Based on the learning theory of collaborativism, different types of collaborative activities are gradually becoming the basic approach in higher education. Examples are student-defined projects, net-based discussion and chat room, seminars, group work, and other forms where interactions among students are seen as central for the learning process. Peer review is one of the possible ways to engage learners in collaborative endeavors. The procedure of peer review creates an interactive network among students so that they monitor, compete with, and learn from each other, and learning therefore becomes an active, collaborative, and participatory process for all students (Shaw, 2002; Nilson, 2003).

Merits of Peer Review

Various reasons account for the popularity of using peer review in writing classes. First, students like it. The analysis of student responses from a posttest questionnaire survey administered by Liu, et al. (2001) revealed that about 68 percent of the participants preferred using peer review for writing assignments. In an end-of-semester survey of 12 students in Eschenbach's (2001) class, 11 recommended that peer review and peer evaluation practice should be continued. Second, peer feedback is known to be associated with better student academic achievement. Learning gains from peer review and peer assessment of writing in terms of test performance and skill performance are frequently reported in the literature (Topping, 1998; MacLeod, 1999). The findings of Richer's (1992) study suggest that using peer review provides a viable method enabling students to enhance their writing skills. Students find peer feedback as good as or better than the instructor's (Mangelsdorf, 1992; Topping). Third, peer review reduces the workload of the instructor. A survey of assessment in an Australian tertiary institution found that the single most common student complaint was insufficient feedback on their written work (Candy, Crebert, & O'Leary, 1994). Circumstances of worsening staff-student ratios make it harder and harder for instructors to provide sufficient, detailed, individualized, and timely feedback on student work. Peer review can be used to eliminate the need for instructors

to read and grade hundreds of student essays. As noted by Topping, peer review is "time saving and substitutional or supplementary to staff assessment". Similarly, Ramsden (1992) emphasizes that it is not always necessary for academic staff to give feedback: students can often learn more from formal or informal assessment by their peers or by themselves. Elbow (1973) even argued for a "teacherless writing class". Robinson (1999) also concurs that peer review roughly halves the professional time required for assessment. Fourth, it is claimed that students plan more extensively and write more carefully when they are communicating with an audience of peers than when they are evaluated solely by the instructor because of peer pressure (Bagley & Hinter, 1992; Kerr et al., 1995; Lin, Chiu, & Yuan, 1999; Eschenbach; Shaw, 2002). There are many other arguments about the potential benefits of students' involvement in peer review process. For example, peer review gives students a sense of ownership of the assessment process, and thus improves students' motivation in learning (Bostock, 2000; Liu et al., 2001); it encourages students to take responsibility for their own learning as well as for others' learning (Mangelsdorf; Topping; Bostock); it offers students opportunities to use external evaluation to provide a model for internal self-assessment of their own learning (Bostock; Liu, et al.); it encourages student autonomy and higher order thinking skills (Bostock; Eschenbach); it helps develop student communication and collaborative skills (Bostock; Eschenbach; Nilson, 2003); it promotes active student involvement in the learning process (Butler, 2001); it offers students opportunities to get multiple feedback from different perspectives (Chaudron, 1983; Kerr et al.; Quible, 1997; Robinson; Bhalerao & Ward, 2000); it cultivates students' assessment skills and critical thinking skills (Kerr et al.; MacLeod; Bostock; Eschenbach; Nilson); it prepares students with professional skills and life-long learning skills (Stefani, 1992; Bostock; Liu et al.; Nilson).

Concerns with Peer Review

Despite the potential benefits to students' participation in peer review, there remain some concerns with the validity, reliability, and objectivity of peer review. The literature suggests that the biggest problem with peer review is that students are easily biased or not honest in giving

feedback because of friendship, gender, race, interpersonal relationship, or personal likes or dislikes (Carson & Nelson, 1996; Zhao, 1998; MacLeod, 1999; Ghorpade & Lackritz, 2001; Nilson, 2003). Students conducting face-to-face reviews frequently express anxiety in sharing their writing for fear of being wrong or being rejected by peers (Zhao), and students find it extremely hard to give negative feedback to their classmates, especially friends to avoid hurting others' feelings or damaging personal relationships (Schaffer, 1996; MacLeod; Topping, 1998). Another area of concern with peer review is the uneven quality of feedback. Kerr et al. (1995) and Robinson (1999) purport that students with better writing ability are better at the task of grading the essays of their peers. Some research claims that students often hesitate to take peers' feedback seriously when they know their peers are less capable writers than themselves even though the comments may be right (Quible, 1997). As many peer review activities are organized in groups, there arise some difficulties with group functioning as well. For example, students often complain the irresponsibility or procrastination of their group member(s) (Dyrud, 2001), and in some other cases, students are more interested in maintaining positive group relations rather than in helping each other with their writing during group interactions (Carson & Nelson), which destroys the value of peer review. In addition, the composition of peer groups also contributes to such difficulties. According to Lou, et al. (1996), low-ability students benefit more from heterogeneous ability groups, medium-ability students benefit more from homogeneous ability groups, and high-ability students benefit equally well in either type of group composition.

To alleviate these concerns, many researchers on peer review interaction advocate some approaches to increase the validity and reliability of peer review, among which are: 1) using electronic format to avoid the possible embarrassment students may experience in face-to-face interaction (Siegel, Dubrovsky, Kiesler, & McGuire, 1986; Mabrito, 1991; Selfe & Meyer, 1991; Eisenberg, 1993; Kelm, 1996; Robinson, 1999; Knoy, Lin, Liu, & Yuan, 2001), 2) using multiple reviewers for any single piece of writing to balance the uneven quality of peer feedback (Kerr et al., 1995; Quible, 1997; Robinson; Nilson, 2003), and 3) using anonymous peer review to minimize opportunities for students to reward friends or otherwise cheat during the peer review

process (Haaga, 1993; Kerr et al.; Vinson, 1996; Zhao, 1998; Robinson, 1999; Bostock, 2000; Bhalerao & Ward, 2000). The primary purpose of the present study is to introduce anonymity in the peer review process to examine whether it can overcome some of the problems with peer review and produce better student writing performance and higher levels of student learning satisfaction.

Anonymous Peer Review

Anonymous peer review refers to a kind of peer review condition in which both reviewers and reviewees are kept unknown to each other. Anonymity is an important component of deindividuation (Zimbardo, 1969; Connally, Jessup, & Valacich 1990). According to the research on social psychology, deindividuation alludes to the situation in which individuals in groups "stop thinking of other members as individuals and feel that they cannot be singled out by others" (Jessup, Connolly, & Tansik, 1990, p. 338). This deindividuation results in a reduction of normal inner restraints and enables group members to engage in behavior that they would not ordinarily display (Jessup et al.). Anonymous peer review, therefore, is predicted to foster deindividuated behavior because the assessment system separates individuals from one another and detaches individuals from their contributions.

Advantages

Using anonymity in the peer review process is not a matter of a principle. It is a practical solution to the task of obtaining the valid comments and hence enabling students to benefit from the feedback. Haaga (1993) found that students providing double-blind reviews of journal manuscripts were more reliable than professional peer reviews. Bostock (2000) also concluded on the basis of the literature review that the accuracy of peer feedback could be improved where assessment is double-anonymous. Zhao (1998) claimed that one possible way to minimize the restraining effects of the fear of being wrong and being rejected by peers is to separate the message from the messenger by means of removal or cancellation of identity, namely by the use of anonymity or pseudonymity.

The major advantage of anonymous peer review suggested by the literature is that it provokes more critical feedback because reviewers are relieved from the social pressure and enabled to express themselves freely without considering interpersonal factors. Researchers believe that constructively critical feedback is more useful in helping students improve their work (Falchikov, 1996). Zhu (1995) points out that if students do not approach their peer's writing critically, they would fail to provide meaningful and useful feedback. It is reported that people feel more comfortable providing critical feedback anonymously than identifiably (Fuller, 1974; Valacich, Dennis, & Nunamaker, 1992; Bornstein, 1993; Zhao, 1998; Bostock, 2000; Liu et al., 2001). Studies have implied that in anonymous situations, people are more honest in expressing their opinions and that anonymity seems to encourage more critical and straightforward expressions in various situations (Stone, Spool, & Rabinowitz, 1977; Zhao; MacLeod, 1999; Bostock). Reviewers in Robinson's (1999) case found it much less stressful to conduct peer assessment in anonymous conditions. Liu et al. also used a blind evaluation in their web-based peer review system to "ensure fairness and willingness to critique" (p. 249). Advocates of reviewer anonymity in the manuscript review process contend that if reviewer anonymity were not maintained, reviewers would be reluctant to submit negative manuscript reviews, particularly when assessing manuscripts submitted by well-known, influential authors (Bornstein). Another interesting finding of anonymous peer review is that students who take a critical approach when reading and scoring a peer's essay are likely to be more critical of their own work and, thus, create an improved product (Kerr et al., 1995). Therefore, anonymity has been identified as an option of a particular virtue in "encouraging expression of unpopular, novel or heretical opinions" (Connolly, 1990, p. 692).

Disadvantages

In spite of the many benefits of anonymity discussed in the literature, it is not without problems. Mixed findings have been identified in the previous studies regarding the characteristics of deindividuation caused by anonymity.

Research on social loafing suggests that anonymity increases social loafing both physically and cognitively. Kerr and Bruun (1981) found that identified group members generally exert greater physical effort than those working anonymously. Similar results were obtained by William, Harkins, and Latané (1981). Their set of experiments all confirmed that less physical effort was made by anonymous individuals, which they called "hide-in- the-crowd" effects. Weldon and Mustari found that anonymity reduced cognitive effort in a parallel "cognitive loafing" paradigm (as cited in Jessup, et al., 1990). Zhao's (1998) two studies with college students that explored the effects of anonymity on peer feedback found anonymity to be a double-edged sword: while it allowed the participants to be more critical, it led them to work less. He concluded that accountability seems to be contrary to anonymity.

Purpose of the Study and the Research Questions

Even though there are a few studies suggesting that anonymity may overcome the problems associated with peer review, most of them focused on the psychological and behavioral consequences of anonymity as a way to enhance the critical nature of student peer feedback, and very few studies investigated the effect of anonymity on student academic achievement and perceived learning satisfaction. Furthermore, hardly any of the previous studies used experimental designs to causally link anonymous peer review with student writing performance and learning satisfaction. This is the rationale for the present study. The purpose of this study was to examine the effects of anonymity on student writing performance and learning satisfaction by using a quasi-experimental design with two college English composition classes. Specifically, the study compared a peer review group in which students gave and received peer feedback anonymously with a peer review group in which students gave and received peer feedback identifiably. It investigated whether the use of anonymity in the peer review process could overcome some of problems of peer review and lead to better student written work and higher levels of student learning satisfaction. In addition, this study might lend support to the findings of previous studies that anonymous peer review invites more critical feedback. Because the whole peer review system was

administered through an electronic communication tool *Blackboard*, it was referred to as "e-peer review" in this study. The following research questions were addressed:

1. Does the use of anonymity in the e-peer review process result in better student writing performance?
2. Do students in the anonymous e-peer review group have higher levels of perceived learning satisfaction than those in the identifiable e-peer review group?
3. Does anonymous e-peer review result in a greater amount of critical feedback?

Significance of the Study

This study would have numerous benefits to research and practice. First, even though peer review has some problems, it has become commonplace in writing environments (Chisholm, 1991). With its increasingly important role in college writing instruction, exploring a more effective and less problematic peer review system to inform classroom practice is of great practical importance. Second, in spite of the relatively wide scope of topics on peer review dealt with by previous studies, research on using anonymity in this field is sparse. In the past, anonymity was a primary concern in psychological research, but it has rarely been considered an important issue in educational research because most educational activities are conducted in face-to-face situations where anonymity hardly exists (Zhao, 1998). Only in recent years has anonymity been brought into classrooms by computer and Internet technology. As Zhao puts it, anonymity is an inherent factor of the ever-increasing use of telecommunication technology in education. Therefore, introducing anonymity in writing instruction is a relatively new arena, and more research is needed to fully discover its potential benefits so as to inform classroom practice. Third, in response to various problems with peer review, most previous studies tried one way or another to cope with them. Compared to the previous studies, the present study takes a more comprehensive approach by taking into consideration the three most commonly advocated solutions to peer review problems—using electronic communication, using multiple

reviewers, and using anonymous peer review—with anonymous peer review as a manipulated variable, while controlling for the other two variables. Finally, the results of this study can contribute to the pool of literature regarding peer review, peer response, and peer feedback or interaction, and may make practical contribution to the writing instruction.

Research Design

This study involved a nonrandomized control-group design. Two intact classes from undergraduate freshmen composition classes were selected by convenient sampling strategy and randomly assigned to the experimental and control groups, with the experimental group giving and receiving peer feedback anonymously, and the control group giving and receiving peer feedback among the group members who were known to one another. The independent variable was anonymous e-peer review vs. identifiable member e-peer review, and the dependent variables were student writing performance, student learning satisfaction, and the amount of critical peer feedback. To minimize group differences, several variables were controlled: the same instructor, same syllabus, same textbooks, same assignments, same tests, same number of reviewers for each draft, and same peer review format—electronic communication (e-peer review).

Student writing performance was measured by the pre-/post-test scores on two timed essay writings and the students' overall course scores. Student learning satisfaction was measured by a questionnaire specifically developed for this study. The amount of critical feedback was measured by the number of negative comments provided for each reviewed draft. To avoid the possible "social loafing" effects caused by anonymity and to increase students' sense of responsibility and accountability in the peer review process, both student papers and their feedback were reviewed and graded by the instructor and contributed to their course grade.

Several limitations with the research design were present in this study. The most salient drawback lay in the non-randomization in its sample selection and assignment. Convenient sampling strategy could not ensure a representative sample, and the sample size (n=24;

n=25) was not large enough to obtain credible results. These factors limited the generalizability of the research results from the sample to the population, and thus threatened the external validity of the study. Additionally, because the subjects were not randomly assigned to the experimental and control groups, selection bias was possible, which might weaken its internal validity. Some other potential threats existed as well, such as, testing, instrumentation, and instructor effects. The detailed descriptions of these threats and the strategies utilized to control them are discussed in the third chapter.

CHAPTER II

LITERATURE REVIEW

This chapter reviews the literature relevant to the research questions in this study. It is organized into five major sections: 1) benefits of peer review, 2) problems with peer review, 3) benefits of anonymous peer review, 4) factors contributing to the critical feedback in anonymous peer review, and 5) feasibility of anonymous peer review made by the electronic communication. At the end of this chapter, a brief summary of the literature, the purpose of the study, and the hypotheses are presented.

Peer review is defined by Gehringer (2000) as students commenting on other students' work, which aims to improve the quality of learning and empower learners. Kerr et al. (1995) look at peer review as *ex ante* evaluation, in which students make comments on their peers' work before final submission to the instructor. Peer review in this study refers to students reading and providing feedback on their peers' drafts with the intention of helping their peers revise and eventually improve their writing by intervening in one another's writing process via peer feedback.

Benefits of Peer Review

A variety of justifications and exhortations have been voiced in favor of student peer review at the tertiary level. These include arguments focusing on the development of student assessment skills, high-level thinking skills, communication skills, collaborative skills, professional and life-long learning skills, emphasizing the importance of student responsibility, autonomy, motivation and peer pressure, and strengthening the efficient use of student or faculty time (Boud, 1995; Kerr et al., 1995; Zariski, 1996; Lin et al., 1999; Bostock, 2000; Lin et al. 2001; Nilson, 2003). The most salient and well-supported benefits of student peer review center around improving student writing skills, and reducing the instructor workload.

Improving Student Writing Skills

The values of peer review in helping students improve their writing skills have been addressed frequently in the literature. Bostock (2000) commented that student assessment of other students' work, both formative and summative, has many potential benefits to learning for assessors and the assessees, because in reviewing others' work, one must read, compare, or question ideas, suggest modifications, or even reflect how well one's own work is compared with others (Robinson, 1999; Eschenbach, 2001; Liu, et; al., 2001; Lindblom-Ylanne & Pihlajamaki, 2003). In doing so, students are more aware of the advantages and weakness of their own work and gain insights in self-assessment (MacLeod, 1999). In Bhalerao and Ward's (2000) case study, ninety percent of students expressed that when they were marking their peers' scripts, they realized mistakes they had made in their own work.

McIsaac and Sepe (1996) incorporated peer review in a writing program with college accounting students. In that writing-across-curriculum course, students were divided into groups of three for peer review. In the peer review session, students came to class with three copies of their papers and exchanged with other group members. The group worked on one paper at a time, beginning by reading the paper by the writer or having everyone quietly read the same paper. After the paper was read, the group discussed it using Peer Response Guide and wrote comments and made corrections directly on the paper. Then, the group moved on to the next paper. The session concluded with a general class discussion. The students and team members reported on their progress. Then the whole class discussed common problem areas in the writing. Following the peer review session, students would revise their papers, and turned in both the draft and the final version so that the instructor could assess their improvement. Based on their teaching experiences, McIsaac and Sepe proclaimed that substantive improvements in student writing were made through the peer review process.

Richer (1992) compared the effects of two kinds of feedback, peer directed and teacher based, on first year college students' writing proficiency. The peer-feedback-only group elicited responses on

their essays from each other, and the teacher-feedback-only group conferenced on their essays with the instructor. Grading of the pretest and posttest essays showed that there was a significant difference in writing proficiency in favor of the peer feedback only group. Ney applied peer assessment to tests, midterms and final exams, and found mastery of the subject matter was due to the peer assessment process (as cited in Topping, 1998).

Peer review is also a common approach in English as Second Language (ESL) writing instruction. Paulus (1999) examined 11 ESL students who used both peer feedback and teacher feedback for the revision of their papers. In his study, students were assigned by the teacher/researcher to work together in pairs based on the levels of student oral and writing proficiency. After writing their first drafts, students participated in a peer review session to give each other feedback on their writing that could be used to revise their work. Students were recorded as they discussed their reactions to the essays. Following the peer review session, students were required to write a second draft of their essays and turned it in to the teacher/researcher for review. Students were then asked to write a third draft based on the teacher/researcher's feedback. Each revision made to the first and second drafts of the essay was analyzed by the teacher/researcher to examine whether the revision was made with peer feedback or teacher feedback, and whether the revision was a surface change or meaning change. On the first draft, a total of 32.3% of the revisions resulted in peer feedback, and 63.3% of these peer-influenced changes were meaning changes. On the second draft, a total of 56.7 of the revisions resulted in teacher feedback, and 59.4 of these were meaning changes. In addition, the first and third drafts on the essays were scored by independent raters to determine whether the overall quality of the essays improved as a result of feedback and revision process. Significant difference was found on the repeated-measures comparison. The findings of the study suggested that both peer and teacher feedback contributed to the revision process, and that writing multiple drafts with help of peer and teacher feedback resulted in overall essay improvement. An earlier study with ESL learners by Chaudron (1983) yielded similar results. This study investigated the effects of different evaluation methods and teacher feedback versus peer feedback on ESL

learners' revisions of their compositions. The revised compositions of 9 advanced and 14 intermediate college ESL students were graded using the ESL Composition Profile. Though no significant difference was found between teacher feedback condition and peer feedback condition, both the intermediate and advanced students showed a similar pattern of improvement from first draft to revision. Along the same line, Mangelsdorf (1992) conducted a study exploring how beneficial peer reviews are for ESL composition students from the perspectives of forty advanced ESL writing students who were asked about their experiences with peer reviews in a questionnaire. The data revealed that for most of the students peer reviews were perceived as a beneficial technique that helped them revise their papers, especially the content and organization. Some students even reported that they found their classmates' comments about their drafts more helpful than the instructor's comments.

Rawson and Tyree (1989) believe that there is a direct relationship between assessment skills and the quality of work that a student produces. This was supported by Liu et al. (2001), who developed an effective web-based learning strategy—web-based peer review (WPR) system and used it with 143 computer science undergraduate students at a Taiwanese university during the spring of 1998. An evaluation of learning effects and students' perceptions about peer review revealed that students not only obtained critical insight from others' work during the review process, but also performed better under a peer review system. The survey results from MacLeod (1999) also indicated that overall, students felt the peer reviews were effective in improving their writing skills. Haaga (1993) used a peer review system in his courses with graduate students. A study of reviews from three of these courses suggested that peer review not only helped students learn to give constructive and substantive feedback to colleagues, but also helped them with their own papers, and the student ratings of the education value of peer review were very high. Given the evidence, Haaga concluded that significant improvement was achieved in students' work as reviewers. Similar arguments were found in Kerr et al. (1995) that students' evaluating abilities as well as the quality of their work appeared to improve with peer review practice.

Reducing the Instructor Workload

Reviewing student writing, giving adequate comments on the piece of writing, and returning it back to the student in a reasonable length of time requires a great deal of the instructors' time. But for formative assessment to be effective, the feedback to the learner must be immediate, timely, individualized and sufficient (Topping, 1998; Bostock, 2000). However, in urban education setting where the student-instructor ratios are usually large, it is very hard for the instructor to provide all the students with timely and sufficient feedback on their writing. In the past few decades, student peer review has been used to alleviate a greater part of the instructor's marking burden, and "makes available swifter feedback in greater quantity" (Topping, p.255). In review of about 109 peer review and peer assessment articles, Topping summarized some of the salient characteristics of peer review and assessment, two of which are "time saving" and "substitutional or supplementary to staff assessment". Both Chaudron (1983) and Richer (1992) conducted studies comparing the effects of teacher feedback and peer feedback on student writing proficiency. The findings suggested that peer feedback was as helpful as or even more helpful than the instructors'. The results of the study by Campbell, Mothersbaugh, Brammer, and Taylor (2001) on peer versus self assessment also demonstrated that peer ratings were directionally more correlated with instructor ratings than self ratings, and thus offered considerable promise in substituting for instructor feedback. McIsaac and Sepe (1996) claimed based on their teaching experiences that the use of peer responses can help alleviate the burden of providing feedback to students on their writing.

Of course, peer review is not just an economical replacement for the instructor assessment. Another aspect of the efficient use of peer review is that it makes it possible for students to get multiple instances of feedback from different reviewers. Bhalerao and Ward (2000) posited that when scripts were multiply marked, it would give students greater confidence in the validity of the comments. In Bhalerao and Ward's case study with an electronically assisted peer-assessment system, feedback was given in triplicate to offer the learners the experience of seeing multiple opinions.

Other Benefits

In addition to the above two most salient benefits of student peer review, some other benefits of peer review were discussed in the literature. Researchers and educators have long argued that peer review is an effective method for developing student life-long learning skills and professional skills (Falchikov, 1996; McIsaac & Sepe, 1996; Bostock, 2000; Nilson, 2003). Throughout their learning and working lives, students will need to evaluate the quality and usefulness of information, and assess the attitude and performance of their subordinates, their peers, their superiors and themselves. Involvement in peer review process can give students valuable experiences in this area, and enable them to make rational and objective judgments in these affairs (Stefani, 1992). Another aspect of the contributions of peer review in preparing students for their future professional life is its resemblance to the real world situation. Peer review, as Liu et al. (2001) claimed, could form an authentic learning environment similar to the journal publication process of academic society in which a researcher submits a paper to a journal and receives reviews from society members before publication. According to social constructivism, students can hopefully achieve deep learning in such an authentic learning environment via social interaction.

Another significant aspect of the peer review process is the use of peer pressure. It is believed that peer pressure stimulates students to compete with each other in positive ways. Lin et al. (1999) posited that some students experienced greater peer pressure in peer review and peer assessment. When they knew that their work had to be reviewed by their peers, they would try their best to do a good job in order to avoid shame and to maintain self-esteem in front of their peers. Therefore, peer pressure, as a motivating factor, may push students to perform better. Shaw (2002) lent his support to this argument through his observations in his years of teaching experiences. He noticed that students really cared about how their works appear to classmates. "I have to do the best I can in the eyes of my classmates" was an often-heard statement from his students. Kerr et al. (1995) endorsed to the argument by adding that students sometimes valued the opinions

of their peers more highly than those of the instructor and that this could lead to better student performance. Eschenbach (2001) found in his teaching practice that at times student performed better for their peers than they did for a grade. Therefore, by holding the students accountable to each other, they seemed to develop a stronger sense of professionalism, accountability and responsibility for their own work. But it should be noted that regardless of various assertions on the effectiveness of peer pressure in enhancing student learning, much of the relevant literature is descriptive, and few outcome data are yet available.

Problems with Peer Review

Despite the various benefits of peer review in student learning, research has implied that some problems and difficulties with peer review must be addressed.

Uneven Quality of Peer Feedback

One of the major concerns with peer review is the uneven quality of peer feedback (Kerr et al., 1995; Robinson, 1999; Nilson, 2003). In evaluating a 2-year program involving peer grading of essay in a principles of microeconomics course, Kerr et al. found that students with better writing ability (marked with higher English ACT scores and GPA in their study) were better at the task of grading the essays of their peers (in better agreement with the instructor grading). In education settings, most peer review process is organized in pairs or small groups (3-5/group), and it is possible that a pair or a group may mostly consist of students with poor writing ability, which means that a number of students would get little useful feedback from their peers. A review of three different feedback systems—written comments, conferences and peer evaluation by Quible (1997) suggests that students doubt whether the feedback they get from their peers is accurate and valuable, and that they often hesitate to take the feedback seriously when they know their peers are less capable writers than themselves even though the comments may be right. Of the negative thoughts expressed by the students about peer reviews in Mangelsdorf's (1992) study, 77% dealt

with the students' lack of trust in their peers' comments to their drafts. This severely destroys the value of peer a review system. To improve the situation, some researchers advocate increasing the number of reviews a student gives and gets to counteract the uneven quality of feedback from different peers (Kerr, et al.; Quible; Nilson).

Group Dysfunction

The literature regarding student group work is rich and varied, and many have noted some problems with group mechanism. Some students are just lazy in studying their peers' work and/or writing up the feedback (Nilson, 2003). Many students express their dissatisfaction with the irresponsibility or procrastination of their group member(s). One of the students in Dyrud's (2001) study reported: "I don't think it is fair that we have been working so hard on this project to have our grade possibly dropped by one person". Some students may even develop a phobia about group work (Dyrud).

The composition of peer groups also contributes to such difficulties. Another concern underlying small-group interaction centers around whether groups should be composed according to student ability, interests, likings, gender, ethnicity, and so on (Lou, Abrami, & Spence, 2000). In educational settings, ability grouping is the most commonly used grouping strategy (Lou, et al.), which includes homogeneous ability grouping and heterogeneous ability grouping. The main rationale for using homogeneous grouping as is often used in ability grouping is to achieve compatibility so that the group can move together at a similar speed. The main rationale for using heterogeneous ability grouping as is often used in cooperative learning is for learners to help one another (Lou et al). Lou et al. (1996), through analyzing 20 independent findings from 12 studies that compared homogeneous ability grouping with heterogeneous ability grouping, reached a conclusion that low-ability students benefited more from heterogeneous ability groups, medium-ability students benefited more from homogeneous ability groups, and high-ability students benefited equally well in either type of group composition. In another study conducted by Lou, et al in 2000 on small-group instruction, it was found that overall higher ability students benefited more from small

group interaction than lower ability students, and elementary students benefited more from it than college students. In light of the findings of these studies, it is obvious that no single grouping strategy can serve all students equally well.

Lack of Criticism in Peer Feedback

It is agreed upon by most researchers that the biggest problem with peer review is the lack of criticism in peer feedback, which largely reduces the validity, reliability and objectivity of peer feedback (Mangelsdorf, 1992; Kerr, et al., 1995; Carson & Nelson, 1996; Quible, 1997; Zhao, 1998; MacLeod, 1999; Bostock, 2000; Bhalerao & Ward, 2000; Ghorpade & Lackritz, 2001; Liu et al., 2001; Nilson, 2003). Students tend to overrate one another, and always feel reluctance to mark down a peer (Falchikov, 1996; Topping, 1998), which is called the "halo error" phenomenon by Farh, Cannella, & Bedeian (1991).

Campbell and Zhao (1996) had two groups of pre-service teachers post their journals to a mailing list and asked the students to read and comment on each other's journals. It turned out that very few comments were of critical nature. Most of them were superficial and affirming. That is to say, students are more willing to compliment than challenge their peers because they "might either be afraid of hurting someone else's feelings or... just be embarrassed" (Bump, 1990, p.57). LaCoste reported that students often felt very uncomfortable when asked to provide critical feedback to their classmates (as cited in Zhao, 1998). The ESL writing students in Mangelsdorf's (1992) study commented that most of the time the reviews by their peers were not critical enough so that not much help could be obtained from such reviews.

The qualitative study by Carson and Nelson (1996) with a group of Chinese students in an advanced ESL composition class revealed that the Chinese students' primary goal for the groups was social. In group interaction, they paid more attention to the maintenance of the relationship that constitutes the group and group harmony among group members. This goal affected the nature and types of interaction they allowed themselves in group discussions. The analysis of the data indicated that when interacting with the members of their groups, the

Chinese students "generally work toward maintaining group harmony and mutual face-saving to maintain a state of cohesion" (p.2), but "such harmony-maintenance strategies may not work toward the development of students' individual writing skills" (p3). The most salient characteristic of the Chinese speakers' interactions was their reluctance to speak and to make negative comments because they did not want to hurt anyone's feelings, because they did not want to generate conflict by disagreeing with their peers, and because they felt vulnerable as readers and writers. They often withheld comments, or tried to soften their critical comments by "under-specifying the writer's problems" or "indirection", which did not always "have the desired effect of helping the writer recognize a problem in his or her writing" (p.16). Their participants talked a lot about not wanting to embarrass the writers. One of them expressed clearly the balance she tried to maintain between the need to not hurt the writer's feelings and her need to say what she thinks about the essays. Carson and Nelson concluded that the Chinese students' concern for the writers' feelings and group harmony made them trade honesty for politeness.

Lindblom-Ylanne &Pihlajamaki (2003) conducted a qualitative study, examining whether a computer-supported learning environment enhances essay writing by providing an opportunity to share drafts with fellow students and to receive feedback from the draft versions. The data from the interviews with 25 law students showed that the students were divided into two groups concerning their experiences towards sharing written drafts with peers: those who were very enthusiastic and enjoyed the possibility to share drafts and those who, on the other hand, felt that the idea of sharing unfinished essays was too threatening for them and required too much openness.

In evidence of the results of past research, the most important reason that prevents students from being critical in providing feedback to their peers is related to the interpersonal factors. Many peer reviewers are unwilling to offer negative comments for fear of damaging personal relationships, being wrong or rejected by peers because of different opinions, or hurting their peers' feelings, especially their friends (Zariski, 1996; Zhao, 1998).

Peer review is organized for the improvement of student writings and its contributions to student learning. These purposes would not

be served by impeding a free flow of constructive comments. Many researchers in writing instruction believe that critical comments are important in helping students improve their writing skills (Zhu, 1995; Schulz, 1996). Zhu posited that because students did not approach their peer's writing critically, they failed to provide meaningful and useful feedback. Schulz commented that in general, the more students are exposed to peer criticism, the more opportunities they have to develop their technical writing skills. Therefore it is of great value and importance to search for an effective strategy in writing instruction to ensure free and straightforward expressions of reviewers so as to increase the validity, reliability and objectivity of peer review. As Kerr et al. (1995) argued, greater objectivity can be obtained through designing a peer review system that minimizes opportunities for student to reward friends or otherwise cheat during the peer review process.

These and other problems and difficulties with peer review have triggered discussions concerning how peer review can be made more effective. There have been a number of proposals for modifications in the peer review process that might help to avoid the "halo error" phenomenon and thus obtain direct, honest and critical peer feedback. Among the proposed modifications, the most popular one is the use of anonymity of reviewers and reviewees (Stone et al. 1977; Connally, Jessup, & Valacich , 1990; Valacich, et al. 1992; Haaga, 1993; Kerr et al., 1995; Vinson, 1996; Zhao, 1998; Bostock, 2000; Bhalerao & Ward, 2000).

Benefits of Anonymous Peer Review

Zhao (1998) advocated the use of anonymity in peer review to increase critical feedback and to make the participants feel more comfortable to criticize. He said that one possible way to minimize the restraining effects of the fear of being wrong and being rejected by peers is to separate the message from the messenger. The removal or cancellation of identity—the use of anonymity or pseudonymity—helps to achieve such an effect. Based on these assumptions, Zhao conducted two studies with college freshmen and sophomores that explored the effects of anonymity on peer feedback. In each of the studies, the

participants were asked to review journal entries by their peers in two conditions: anonymous and identifiable. In the anonymous condition, the identification of both the reviewers and authors were removed so that the reviewers were not aware of the authorship of the writings they reviewed, and they were assured that their reviews would be anonymous to the authors. In the identifiable condition, the reviewers were aware of the authorship of the journals they reviewed and that their reviews would be given to the authors with their names attached. His studies systematically examined the psychological and behavioral consequences of anonymity as a way to enhance the critical nature of student peer reviews. The measurement of the three indicators—the grades assigned to each journal by peer reviewers, the degree of the overall critical nature of the peer comments as rated by two experts, and the recipients' perceptions of the degree of negativeness or rudeness of the peer feedback they received—confirmed his assumptions that the reviews provided in the anonymous condition were more critical than those made in the identifiable condition.

The work by Valacich et al. (1992) showed similar results. Their experiment tested the effects of group size (3 and 9 members) and group member anonymity on group idea generation using a computer-mediated idea-generation system. Measured by the number of "expressions of opposition to a proposal with, or without, evidence or arguments" (p. 59), both a significant main effect and interaction effect were obtained from the experiment: anonymous group members were more critical than identified group members; members of large groups were more critical than members of small groups; small-identified groups were the least critical. Valacich et al. further analyzed that the reason why larger groups provided more critical comments was due to the effects of anonymity: members of larger groups may have felt virtually anonymous. This conclusion was further confirmed by an empirical investigation by Connally et al. (1990), which found that anonymous groups generated more unique critical ideas and more overall comments than nonanonymous groups.

Research on student evaluation of faculty performance supported the idea that required signatures would introduce bias and thus reduce the validity of evaluation. McCollister's (1985) interview study with 50 college medical students revealed that "the requirement of signed

evaluations was sufficiently threatening to students to cause them to temper their evaluations and comments" (p.354). Based on his findings, McCollister claimed that in the interest of validity, anonymity of student evaluators is worth protecting. A survey study by Stone et al. (1977) supported the work of McCollister. Stone et al. administered a specially developed instrument, Faculty Evaluation Form, to 188 university students, examining whether anonymity had impact on student ratings for their professor. A hypothesized effect was found that there were more positive ratings by students who signed their names on the forms than those who rated anonymously. In *The Efficacy of Several Writing Feedback Systems*, Quible (1997) put forward that students might inflate the rating of others' writing, especially when they have to put their names on the paper they evaluate. His anecdotal evidence indicates that maintaining the anonymity of the writer and the evaluator in the process of peer review was preferable by his students to allowing their true identity to be known.

The use of anonymity in providing feedback is not confined to educational settings. It has been employed in other professional fields as well. For example, the web-based multi-rater assessment system, 360-degree feedback, is becoming increasingly popular in business world. It is so called because feedback is provided by people 'all around' an employee (Nowack, 1993). To insure that 360-degree feedback has a better chance of producing a change, Vinson (1996) contends that the feedback must be anonymous and confidential so that truthful, straightforward and specific feedback can be obtained.

In response to the criticism against anonymous manuscript review system that reviewers and journal editors are biased against unpopular and counter-attitudinal findings, and against unknown authors and authors from less prestigious institutions, Bornstein (1993) conducted a survey to examine the costs and benefits of reviewer anonymity. One hundred and eighty journal editors and reviewers completed a 48-item questionnaire. It turned out that in general, respondents had negative opinions regarding an "open review" system wherein reviewers' identities were revealed to the authors of submitted manuscripts. Respondents indicated that open reviewing would "decrease reviewer objectivity, would result in less rigorous reviews, and would decrease the overall quality of manuscript reviews" (p.365).

Fuller (1974) also assessed the effects of anonymity and identification on the responses of naval officers and enlisted men. Nearly 42,000 questionnaires were mailed to the potential participants, and 16,590 questionnaires returned. The results showed that pro-Navy statements were endorsed by a higher proportion of the officers who could be identified with their answer sheets, and negative statements were endorsed by a higher proportion of the officers who could not be identified with their answer sheets.

In addition to inviting more honest, straightforward and critical feedback, the use of anonymity is also believed to have positive influence on student academic achievement. Pelaez (2002) conducted a study comparing the effects of two instructional approaches—problem-based writing with anonymous peer review (PW-PR) vs. traditional didactic lectures followed by group work (traditional instruction)—on student performance on physiology exams. The author taught both PW-PR and traditional portions of the course in the spring of 2000. Thirty-five students enrolled in Biology 310 participated in the study. Multiple-choice and essay exam questions were used to measure student achievement. Paired t-test comparisons of means showed that student performance was better on multiple-choice measures and equal or better on essay test items for concepts taught using PW-PR compared with concepts taught using traditional instruction. Along the same line, Guilford (2001) applied anonymous peer review for teaching undergraduate students the full scientific publishing process during the process of writing a term paper. In this study, the students were required to prepare a review article on a self-chosen topic by the mid-semester. The first draft of the article was given confidentially to two other students in the class as well as the instructor for critique. Within two weeks, peer reviewers' critiques were returned to the instructor and were given back to the authors together with a summary from the instructor. Then students revised their first draft based on the peers' critiques and the instructor's comments and submitted the final manuscript along with a point-by-point response to their reviews for the instructor grading. At the end of the semester, students were asked to numerically score their agreement or disagreement with several statements about their experiences with this peer review process. The survey results indicated that students strongly agreed that their course

grades and the quality of their papers improved as a result of this teaching method. Similarly, Lightfoot (1998) used peer review with his college students enrolled in a one-semester long psychology course. On the first day of class, students were assigned an article chosen from a scientific journal in their discipline, and were required to write three two-page critiques of the article at three different times in the semester. The critiques were then distributed to other students by the instructor for peer review using double-blind system (for the first critique), single-blind system (for the second critique), and open review system (for the third critique). Although no formal assessment procedures were put into place specifically to look at the efficacy of this experiential exercise, in the last two classes in which this peer review method was used (n = 58 students), the students exhibited an average 17% increase (p < .002) in their grades from their first critique paper to their third critique papers.

Furthermore, some other benefits of anonymous peer review were documented in the literature. Haaga (1993) found that students providing double-blind reviews of journal manuscripts were more reliable than professional peer reviews. Bostock (2000) concluded after reviewing the relevant literature that the accuracy of peer feedback can be improved where assessment is double-anonymous. Anonymous peer review has also been found to be welcomed by students. MacLeod (1999) chose to use anonymous peer review in his business communication classes because 76% of the student expressed their preferences for it in a survey. Robinson (1998) attempted to address peer-review problems via an anonymous peer review system in a large class with 150 second-year students. Authors and reviewers anonymously reviewed each others' term papers, and both papers and reviews were assessed. Students were surveyed after the assessment was complete. They showed an overwhelming preference for anonymity. Most students regarded the approach as fair. On the basis of the results of his study, Robinson argued that the difficulties with peer review and peer assessment could be answered by anonymity and multiple reviewers (working much as peer review for journal publications).

Factors Contributing to the Critical Feedback in Anonymous Peer Review

According to the past literature, the most salient and important advantage of anonymous peer review is to obtain more honest and direct expressions from reviewers, and to give more critical and constructive appraisal of others' work (Zhao, 1998). Several factors have been identified contributing to such characteristics of anonymous peer review.

Deindividuation Caused by Anonymity

Literature suggests that anonymity can contribute to deindividuation—the kind of feeling of becoming submerged in the group, of losing awareness of one's own individuality and that of other group members (Connolly et al., 1990). One of the characteristics of deindividuation caused by anonymity in peer review process is the relief of reviewers from social pressure (Zhao, 1998; Robinson, 1999). It has been illustrated by several studies that individuals behave more freely and feel much less stressed in anonymous situations than in situations where they are identifiable because of the deindividuating effects.

Grounded in social psychological research in deindividuation, Jessup and his associates administered three laboratory experiments to investigate the effects of GDSS (Group Decision Support System) anonymity on group process and outcome (Jessup, et al., 1988; Connolly, et al., 1990; Jessup, et al., 1990). Subjects in these studies were students from an upper-division, core business school organizational behavior course. They worked in groups of 4 members and used the electronic brainstorming program to generate and evaluate workable solutions to the university's parking problem. Subjects in the identified condition could clearly see that their names would be attached to every comment they typed in and identified by other group members. Subjects in the anonymous condition could clearly see that all contributions were completely anonymous. The results from the three studies supported one another: group members working anonymously generated more solution clarifications, more critical comments, and more total

comments than groups working under identified conditions. In analyzing these studies in their 1990 article, Jessup et al. posited that "anonymous interaction has deindividuating effects on group process" (p. 333) and "may be beneficial in promoting a free-flowing exchange of ideas and opinions" (p. 341).

The results of studies on anonymity also fit with the deindividuation explanation of relieving individuals from social pressure. Jessup et al. (1990) offered an example in organizational behavior to illustrate the advantages of anonymous interaction in this respect. They said that by using anonymous interaction, executive planners could begin their strategic planning by generating and valuating ideas knowing that he or she would not be ridiculed for contributing what others might feel is a silly idea. Further, when evaluating other group members' ideas, the executive could do so freely, without deference to a powerful player's bad idea.

In 1999, Bostock (2000) carried out a study on anonymous peer review. Thirty-eight students placed their "draft" instructional application on their web space, from which four assessors per reviewee provided reviews against five criteria. Sixteen students returned an anonymous evaluation of the reviews. For most of them, some or all the review had been useful, because "anonymity allowed some reviews to be ruthless"(p.2).

In response to a common complaint from his students about the peer review process that they found it exceedingly uncomfortable to give people they knew objective feedback, Haaga (1993) concealed the identities of reviewers and reveiwees from each other in his courses with graduate students to ensure objectivity. A study of reviews from three of these courses suggested that anonymous peer review not only helped students with their own papers, but also helped them learn to give constructive, substantive and critical feedback to colleagues. Student anonymous ratings of the educational value of anonymous peer review were high on the survey completed by the students on the last class day.

The results of an interview study by McCollister (1985) revealed that a relatively large number of student participants (40%, n=50) felt that they would have been greatly inhibited in responding to the questions on quality of teaching and personal rating of their teachers

if they were required to sign their names on course evaluations.

Based upon the results of their study that there were more positive ratings by students who signed their names on the evaluation forms than those who rated anonymously, Stone et al. (1977) claimed that students might not feel free to honestly rate the performance of a faculty member in identifiable condition because they might fear that he or she would retaliate against them in some way for the ratings. Therefore, response bias could be present in signed students ratings. A study by Kelm (1996) revealed that anonymous interaction assisted by the computer technology helped second language learners break down communication barriers and inhibitions that they often experienced in traditional classrooms, and thus made them feel comfortable in expressing their ideas in second language.

Detachment of the Messenger from his Messages Caused by Anonymity

Another important reason why reviewers can be open, straightforward and critical in providing feedback to their peers in anonymous condition is due to the fact that anonymity helps separate individuals from their contributions.

The participants in Zhao's (1998) two studies exploring the effects of anonymity on peer feedback were found to be able to focus more on the journals than the authors of the journals when providing feedback anonymously, while the opposite was true with the participants in the identifiable condition. One subject in Jessup's study (1990) expressed the similar effects of anonymous peer review from the viewpoints of a reviewee. She said that she liked the anonymous GDSS (Group Decision Support System) interaction because when someone criticized her comments she felt that they were focusing on the content of the comments, and not on her personally. She thought this was much less threatening than criticism in face-to-face environment. An even earlier study on Nominal Group Technique (NGT) by Delbecq, Van de Ven, and Gustaffson (1975) indicated that when group members could separate authors from specific ideas, they could judge ideas on their merit, not on the influence of their authors. Anonymous peer review definitely provides reviewers the opportunity to separate authors from

their writings so that free flow of critical feedback can be evoked.

Feasibility of Anonymous Peer Review
Made by the Electronic Communication

The anonymous peer review among students seldom receives any serious attention from researchers because in educational settings where most of instructional activities are conducted in face-to-face situations, it is almost impossible to organize anonymous collaborative activities (Zhao, 1998). However, the increasing use of computer networks in education has changed the whole scenario: it has not only made it possible for individuals to work together anonymously using net-worked computers, but also demonstrated its unique advantages in processing peer review system.

The importance of using technology in writing instruction has been recognized by researchers and educators. At the 1997 Conference on College Composition and Communication (CCCC), approximately one-third of the 500 sessions addressed innovative ways to combine technology and writing and the benefits from a concerted effort to bring writing and technology together (CCMP report, 1999). In the past few years, electronic peer review (e-peer review), that is, the collaborative work of student peer groups who review one another's work with the intention to improve their peers' work as well as their own work via electronic communication, has become the highlight of the writing course (Strever & Newman, 1997).

Electronic communication presents several advantages over the traditional face-to face communication. The first, and maybe the most unarguable advantage is its flexible, convenient, and time-efficient character. Electronic writing environments expand the boundaries of the classroom, and enable students to communicate both in or out of the classroom, and with or without the presence of writers and readers. Messages can be posted, read, and responded to at the writers' and reviewers' convenience.

Tannacito's (2001) extensive qualitative data showed the students really liked completing peer response electronically. In analyzing the data from class discussion, teacher-student conferences, and online survey feedback, he found three primary reasons contributing to this

phenomenon: 1) students were enthusiastic about computers and had a lot of fun in electronic communication, and because they enjoyed the process of electronic peer review, they enjoyed writing; 2) students thought they could provide much better responses electronically rather than orally because they could look at the essay closely and take a moment to decide how to phrase their suggestions; 3) students found it more helpful and convenient to have a written record from electronic responses than from oral responses when revising their drafts because it could help avoid forgetting their peers' comments which was often the case in traditional face-to-face meetings.

In the business world, managers and emplyoyees often spend a great deal of unproductive time in meetings (Dennis, George, Jessup, Nunamaker, & Vogel, 1988). Dennis and his colleagues cited an example in his article that one Fortune 500 company estimated that it lost $71 million each year due to ineffectively managed meetings. As a result, there is now a rapidly growing interest in using electronic communication to replace traditional meetings, which allows more efficient interaction among participants (Jessup, et al., 1990).

Another important advantage of electronic communication is its function in promoting more and equal participation among group members. In face-to-face meetings, the proportion of participation is usually predicted by group members' different social position or personal competencies or personally dominating style (Hiltz, Johnson, & Turoff, 1986; Siegel, et al., 1986; Mabrito, 1991). Hiltz et al. found through their experiments that because of lacking nonverbal cues or any suggested procedures for generating a leader, the computerized communication did not develop any dominant participants, whereas dominant individuals or leaders did emerge for most of the face-to-face communications. The research in computer-mediated communication in classroom settings suggests that electronic communication removes the physical presences of writers and readers, and the racial, gender, class and language barriers that can impede productive dialogue, and provides more interactive opportunities for all students, especially for those quiet and less-able students (Hartman, et al., 1991; CCMP report, 1999). Langston and Batson (1990) provided another case supporting this idea. As their pilot study's most significant conclusion, they said: "we found indications that groups working online will show

a more evenly distributed interactive pattern than face-to-face groups" (p.146). Siegel, et al. (1986) designed three experiments comparing computer-mediated communication with face-to-face communication. The results showed that groups communicating via computer showed more equal participation among group members than did face-to-face groups, and that groups using the computer to communicate were more uninhibited than were the same groups communicating face-to-face. Further, an increase in student participation and more directions provided for revision have been found in electronic communication by Kelm (1992), Chun (1994), Kern (1996), and Mabrito (1991).

Some other advantages of electronic communication have also been discussed in the literature. Lin and his associates (Lin et al. 1999; Lin et al. 2001) did a series of studies on Web-based peer review and found it an effective learning strategy and related with students achievement. The research in computer-mediated communication has indicated that participants in electronic environments retain more information than they do from face-to-face meetings because people generally retain more from reading than listening (Hiltz & Turoff, 1978). The work by Hiltz and his associates (Hiltz et al., 1986) also indicated that the electronic communication provided a more effective delivery system for peer evaluation than the face-to-face meetings for both writers and reviewers of writings. Mabrito (1991) claimed that students relied more on comments received during email sessions than comments received during face-to-face sessions. Felix (as cited in Heift, 2000) found that students scored higher on the logical thinking of ideas when using networked writing environments as opposed to face-to-face instruction because they have more time to think and more opportunities to revise. Tannacito (2001), on the basis of the analysis of his students' comments from a variety of sources including the comments his students made in the online asynchronous discussions, in their emails to him, in the conferences with him, on the writing process forms, and in the final documents submitted to him, came to a conclusion that both the quantity and quality of the students' comments and revisions improved with the peer review process.

Of course we cannot forget the unique contribution of electronic communication in making anonymity a reality in educational settings. As a matter of a fact, it has not only made it easier to conduct anonymous

collaborative activities, but also made it a growing phenomenon and dramatically raised the status of anonymity as an issue of inquiry in educational research and practices (Zhao, 1998).

Summary and Hypotheses

In summary, students can benefit from participating in a peer review process. At the same time, there are potential problems regarding the validity and reliability of peer feedback. One way to cope with these problems is to introduce anonymity into peer review process with the help of electronic communication so as to minimize the negative consequences while preserving the positive effects of peer review.

Based on the findings of previous studies on anonymous peer interaction that anonymity leads to the sense of deindividuation so that people feel free to provide critical feedback, the present study intended to move a step further to examine the effects of using anonymity in the peer review process on student writing performance. It also was aimed to investigate student perceived satisfaction about the anonymous peer feedback, and whether such perceptions affected the levels of their satisfaction towards the course the assessment system, and peer feedback. The research design allowed as well the comparison between the two groups to see whether anonymous peer review invited a greater amount of critical peer feedback than identifiable peer review. The specific hypotheses are:

1. Students in the anonymous e-peer review group will show greater improvement in their writing test scores than those in the identifiable e-peer review group.
2. Students in the anonymous e-peer review group will have higher course scores than those in the identifiable e-peer review group.
3. Students who give and receive e-peer feedback anonymously will have higher levels of perceived satisfaction with the course than those who give and receive e-peer feedback identifiably.
4. Students who give and receive e-peer feedback anonymously will have higher levels of perceived satisfaction with the

assessment system than those who give and receive e-peer feedback identifiably.

5. Students who give and receive e-peer feedback anonymously will have higher levels of perceived satisfaction with peer feedback than those who give and receive e-peer feedback identifiably.

6. There will be a greater amount of critical peer feedback provided by students doing anonymous e-peer review than by those doing e-peer review identifiably.

7. Students doing anonymous e-peer review will tend to give lower scores on their peers' writings than those doing e-peer review identifiably.

CHAPTER III

METHODOLOGY

This chapter describes the methodology used in collecting and analyzing data for this study. Research hypotheses are presented. Information on the research design, population and sample, instruments, procedure, and data analysis are included along with the reliability and validity of measures.

Research Design

The present study, employing a quasi-experimental design, was intended to determine whether an experimentally manipulated variable—anonymous e-peer review—would result in improved student writing performance, higher student learning satisfaction, and greater amount of critical peer feedback. There is one independent variable—anonymous e-peer review vs. identifiable e-peer review, and three dependent variables—student writing performance, student learning satisfaction, and the amount of critical peer feedback. Data were obtained from 49 students at a large urban university. The research hypotheses are:

1. Students in the anonymous e-peer review group will show greater improvement in their writing test scores than those in the identifiable e-peer review group.
2. Students in the anonymous e-peer review group will have higher course scores than those in the identifiable e-peer review group.
3. Students who give and receive e-peer feedback anonymously will have higher level of perceived satisfaction with the course than those who give and receive e-peer feedback identifiably.
4. Students who give and receive e-peer feedback anonymously will have higher level of perceived satisfaction with the assessment system than those who give and receive e-peer feedback identifiably.

5. Students who give and receive e-peer feedback anonymously will have higher level of perceived satisfaction with peer feedback than those who give and receive e-peer feedback identifiably.

6. There will be greater amount of critical peer feedback provided by students doing anonymous e-peer review than by those doing e-peer review identifiably.

7. Students doing anonymous e-peer review tend to give lower scores on their peers' writings than those doing e-peer review identifiably.

The researcher used a nonequivalent control group design with pre-/post-tests and post-treatment survey as depicted in Table 1 to test the hypotheses.

Table 1
Nonequivalent Pre- and Post-test Control Group Design

Group	Writing Pre-test	Treatment	Writing Post-test	Course Scores	Post-treatment Survey
Anonymous	X	Random Anonymous e-Peer Review	X	X	X
Identifiable	X	Identifiable Member e-Peer Review	X	X	X
		Duration: 14 Weeks			

The variables used in this study are summarized in Figure 1.

Figure 1. The Variables of the Study

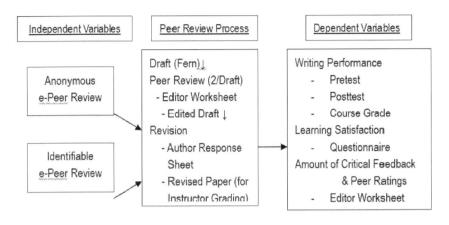

Participants

The target population for this study was main campus undergraduate students enrolled in English composition classes in urban public universities. The experimentally accessible population for this study consisted of approximate 800 main campus undergraduate students enrolled in 42 English Composition classes at an urban university in an eastern state. Students must pass the *Writing Sample Placement Test (WSPT)* administered by the Writing Center of the University in to be placed in these classes. The purpose of the WSPT is to evaluate the writing abilities of all incoming degree seeking students.

The sample for this study involved two English composition classes, one professor and 49 students. Two intact classes were identified for the experiment from the 42 English Composition classes by using convenient sampling strategy. The two classes had same number of students (n = 24, n = 24). One class met from 11:00 a.m. to 12:15 p.m. every Tuesday and Thursday, and the other met on the same days from 1:30 p.m. to 2:45 p.m. The two classes were randomly assigned to the experimental and control groups by a coin toss. The experimental group gave and received anonymous e-peer feedback, while the control group gave and received identifiable e-peer feedback among group members. The whole peer review process was carried out through electronic communication (electronic peer review: e-peer review) via a web-based learning tool *Blackboard*.

Instrumentation

Student Writing Performance

Student writing performance was measured by the pretest and posttest scores on two in-class essay writings, and the student overall course scores.

Both pretest and posttest included timed in-class essay writing on given topics (400-500 words in 75 minutes). The assessment of the pretest served as a baseline for the posttest assessments. In order to control for the testing threats to the internal validity, two different essay topics were used for the pretest and posttest. Papers from both the pretest and posttest were coded and shuffled by the researcher before delivering to the scorers. Student names did not appear in their papers. Two professional scorers from the university Writing Center, who were totally blind to the experimental conditions independently graded the pretest and posttest papers using Ransdell-Levy's writing evaluation rubric—Six-Subgroup Quality Scale (SSQS) (See Appendix A). The two raters have received special training on assessing student writings, and they have scored the university writing Sample Placement Test for years (this is the kind of test based on which students are placed in English Composition classes).

The Six-Subgroup Quality Scale (SSQS) is a set of holistic quality rating scales based on reliable ratings of 13 dimensions of writing success in six subgroups—Words: Choice and Arrangement, Technical Quality: Mechanics, Content of Essay, Purpose/Audience/ Tone, Organization and Development, and Style (Ransdell & Levy, 1996). Appendix A presents a description of the six subgroups and the specific values assigned to each dimension on a 5-point scale.

SSQS was "adapted from a university-level English placement exam. Evidence suggests that the measure is both reliable and valid with college-level samples. Its typical interrater r's are in the .80s and .90s across all 13 dimensions (Ransdell & Levy, 1996). For concurrent validity, Ransdell and Levy conducted three experiments with 139 subjects and found that the SSQS consistently predicts Nelson-Denny reading comprehension scores. To maximize the interrater reliabilities

for this study, the two scorers were trained to follow the assessment procedure used by Ransdell and Levy in the grading: the two scorers first discussed the 13 dimensions included in SSQS thoroughly; then they randomly selected several papers from both pretest and posttest, and tried grading them by providing analytical ratings for each particular dimension in the order in which they are presented on the scale; next, they read all the essays to get an idea of the overall range in holistic quality; then they independently scored each paper. Any ratings different by more than two points on the 5-point scale were discussed by the two scorers to reach agreement. According Ransdell and Levy, quite high interrater reliabilities can be achieved with this procedure. The inter-rater reliability of the two scorers in this study was .64 as measured by Pearson-product-moment correlation. The average of the two ratings for each paper served as the final score of the paper.

Student Learning Satisfaction

Student learning satisfaction was measured by a survey questionnaire—Student Learning Satisfaction Questionnaire (see Appendix B). The questionnaire was developed by the researcher based on the literature review to reflect how subjects felt about their learning experiences in the course they attended. This questionnaire includes 38 close-ended and open-ended items in four domains: Perceived Satisfaction with the Course (10 items), Perceived Satisfaction with the Assessment System (12 items), Perceived Satisfaction with Peer Feedback (11 items), and Open-ended Questions (5 items). See Table 2 for the matrix of the questionnaire.

Table 2

The Domains of Student Learning Satisfaction Questionnaire

Domains	Items
Demographic Information	13
Satisfaction with the Course	10
Satisfaction with the Assessment System	12
Satisfaction with Peer Feedback	11
Open-ended Questions	5

All close-ended items were scored on a scale of one to four (1 = Strongly Disagree, 2 = Disagree, 3 = Agree, 4 = Strongly Agree). A four-point Likert scale was chosen to compel a forced choice of positive or negative response for each item. Items 14, 20, 31, and 32 were reverse scored (1 = Strongly Agree, 4 = Strongly Disagree). The open-ended questions were probing in nature, aiming at initiating some specific individual comments, such as, student perceptions of peer feedback, student perceptions of the advantages and disadvantages of e-peer review, and how to improve peer review system. In addition, student demographic information, such as, gender, age, class standing, GPA, academic major, race/ethnicity, former writing training experiences, and the reason for course enrollment, was also included in the questionnaire to help ensure that the two groups were equivalent to some extent before the treatment. For the experimental group, two extra close-ended items checking the anonymity manipulation were added to the end of the questionnaire.

Reliability and validity. The content of the questionnaire was reviewed by a panel of three professors with expertise in the field of research design and educational curriculum and instructional design, and four doctoral students. The instrument was pilot tested with 110 campus undergraduates taught by the same instructor in the early fall semester of 2003. Reliability was checked using Cronbach's alpha. The internal consistency (alpha coefficient) for all rating scales derived from the 110 students ranged from .80 to .98 across the domains. For the construct validity of the questionnaire, principal components with varimax rotation was performed on the responses from the pilot test to determine if the items were associated with their respective domains, and whether the items were clear. The original questionnaire consisted of 40 close-ended items in four domains: student satisfaction with the course (10 items), student satisfaction with the assessment system (10 items), student satisfaction with peer feedback (10 items), and student satisfaction with learning achievement (10 items). As the domain of "student satisfaction with peer feedback" was not applicable to the pilot-test participants, this domain was deleted from the questionnaire in the pilot test. The results of the principal components analysis indicated that 8 out 10 items in "student satisfaction with the course" clustered together as one factor, with 36% of variance explained by

this factor. Nine out of 10 items in "student satisfaction with the assessment system" formed a second factor, which accounted for 29% of total variance (See Table 3). As the items in "student satisfaction with learning achievement" were split among the 3 domains, some of them were placed in the other two domains, and the rest were deleted. As a result, this domain was not included in the final questionnaire. Although some items loaded on both factors, the items were retained if they loaded much more heavily on one factor versus anther. Only one item had a factor loading greater than .50 on both scales.

Table 3

The Results of Factor Analysis of the Reported Satisfaction with the Domains of the Questionnaire

Items	F1: Satisfaction with Course	F2: Satisfaction with Assessment	% Variance Explained
Satisfaction with course			36
S_Course 1	.81		
S_Course 2	.77		
S_Course 3	.80		
S_Course 4	.70		
S_Course 5	.76		
S_Course 6	.83		
Items	F1: Satisfaction with Course	F2: Satisfaction with Assessment	% Variance Explained
S_Course 7	.81		
S_Course 8	.50		
Satisfaction with assessment			29
S_Assessment 1		.79	
S_Assessment 2		.66	
S_Assessment 3	.55	.68	
S_Assessment 4		.53	
S_Assessment 5		.84	
S_Assessment 6		.67	
S_Assessment 7		.70	
S_Assessment 8		.81	
S_Assessment 9		.72	

Note: Factor loadings .50 or above reported.

The Amount of Critical Peer Feedback

In this study, "feedback" refers to remarks, comments, suggestions, questions, and corrections that students provided on their peers' drafts for the purpose of revision. "The amount of critical peer feedback" was operationalized as: 1) the number of negative remarks, comments, suggestions, and 2) the suggested ratings that each peer reviewer gave on each draft. The amount of critical peer feedback was measured based on the e-peer feedback provided in the *Editor Worksheet* (see Appendix C) and the *edited draft* (see an example in Appendix D). *Editor Worksheet* was developed by the instructor, which had been used for peer editing in this course for several years. This writing-evaluating rubric consists of three parts: 1) suggested ratings for the overall quality of the reviewed draft, ranging from 1 (lowest quality) to 15 (highest quality) based on which peer ratings were recorded, 2) separate ratings for the quality of each of the nine dimensions (Focus, Organization, Content, Usage, Style, Example, Diction, Interest and Tightness, abbreviated as FOCUS EDIT) of the reviewed draft, ranging from 1 (lowest quality) to 4 (highest quality), and 3) specific comments on the reviewed draft based on the FOCUS EDIT criteria from which the number of negative comments were counted. The *Edited draft* referred to the reviewed draft with the reviewer's specific comments embedded in it. These documents were examined to reveal whether students in anonymous e-peer review group tended to provide greater amount of critical feedback and give lower ratings on their peers' work since the literature suggests that anonymity helps relieve individuals from social pressure and thus leads to free flow of self-expression and more critical feedback (Nilson, 2003; Ghorpade & Lackritz, 2001; MacLeod, 1999). In order to increase the accountability and reliability of peer feedback, the *Author Response Sheet* was developed by the instructor especially for this study with the assumption that since reviewees need feedback to improve their writing skills, reviewers should need feedback to improve their "feedback" skills (see Appendix E).

Procedure

Administration of the Treatment

The first two weeks of the class were used for the orientation. In the first class meeting, students were introduced to the course syllabus and the purpose and procedures of the experiment. Students in the control group (identifiable group) were randomly divided into groups of three and the groups stayed together for the entire semester, while in the experimental group (anonymous group), each student was given a 4-digit identification number (Class ID), which was used in all the paper work instead of his/her name throughout the semester. To assure anonymity, it was clearly written in the syllabus that the Class ID was personal information, and that sharing it with other students was a violation of the Course Honor Code, and those who did it would jeopardize their course grade. Table 4 presents the major treatment differences between the experimental and control groups.

Table 4

Treatment Differences between the Anonymous e-Peer Review Group and the Identifiable e-Peer Review Group

Treatment Administration	Anonymous Group	Identifiable Group
Grouping	The whole class as a group	Randomly divided into groups of three
Access to each other's work	Instructor & the whole class	Instructor & group members
Peer Reviewing	Double blind review on the basis of random-rotating assignments	Group member review
Paper identification	Using one's Class ID in all paper work	Using one's name in all paper work

Because two intact classes were involved in the study, group differences before the experiment were possible. So a pretest was administered to the students in both groups during the second class meeting (August 28) to control for the potential pre-existing group

differences in writing performance before the treatment. The posttest was administered at the end of the semester (December 2) to the two groups to gauge the improvement as a result of the treatment. In order to encourage sincere and responsible writing in the pre-and post-tests, students were told that their pre-and post-test papers would be scored by both the instructor to contribute partly to their course grade, and by the professional scorers for the purpose of the research, which would be independent of their course grade.

For the peer review system to be successful, the two class meetings in the second week were set aside for training. The research shows that training students for peer_review has a significant impact on both the quantity and quality of feedback students provide on peers' writings (Zhu, 1995). The training of peer review skills in this study was accomplished in a variety of forms at various stages in this course. The second week was specially used to familiarize students with necessary computer skills and peer review techniques. The follow-up trainings, such as, providing detailed written handouts on evaluative criteria (see the Course Syllabus in Appendix F) to guide students both in completing their drafts and commenting on their peers' drafts, explaining the requirements of each writing assignment, and a step-by-step training on how to edit their peers' drafts and how to give meaningful feedback to their peers, were incorporated in class instruction by the instructor.

From the third week on, the students started to undergo the peer review process. Both class sessions followed the same schedule and completed the same types of assignments. There were 9 assignments throughout the semester, eight of which required peer review (one served as a mid-term examination which was graded only by the instructor). Students in both groups were required to complete one assignment per week except the Fall Break week, the Thanksgiving holiday week, and the last two weeks (used for the posttest on student writing performance, the questionnaire survey on student learning satisfaction, and the final). For each assignment, each student reviewed two drafts of their peers and in exchange, each student's draft was reviewed by two peers. The purpose of employing the multiple review system was to provide the students with multiple sources of feedback and also give them multiple opportunities to learn from reviewing

their peers' work. The literature suggests that using multiple reviewers can balance the uneven quality of peer feedback (Kerr, et al., 1995; Robinson, 1999; Nilson, 2003). The full credit for each assignment was 100 points. The instructor decided the grade of each assignment for each student on the basis of three factors: the quality of the revised paper the student wrote (40 points,), the quality of the feedback the student provided for the two reviewed drafts on the *Editor Worksheet* and the edited drafts (15 points × 2 drafts for 30 points), and the quality of the feedback the students provided for each of his/her editors (15 points × 2 editors for 30 points) (see Course Grading Sheet in Appendix G). Students posted their drafts, *Editor Worksheet, Author Response Sheet*, and revised papers on *Blackboard* on the due dates, and any piece of late work would cause 40 points deduction from the 100 total points for each assignment which could not be made up.

The post-treatment questionnaire was administered to both groups at the end of the semester (December 2) to assess the levels of satisfaction students had about a range of factors relating to their learning experiences in this course. A cover letter was attached to the questionnaire to explain to the students the purpose of the survey and the importance of their responses. Students were also assured the confidentiality of their responses and that their responses would in no way affect their course grade. To increase the response rate, the questionnaires were completed in class with the researcher present. Data collection schedules are depicted in table 5.

Table 5
Data Collection Schedule

Data Type	Due Date	Method	Total number collected
Pre-test Administration	Aug. 28	In-class Writing	24/Group
Drafts Submission	Mondays	*Blackboard* Posting	24×8/Group
Editor Feedback Submission	Wednesdays	*Blackboard* Posting	24×2×8/Group
Author Response Submission	Fridays	*Blackboard* Posting	24×2×8
Revised Paper Submission	Fridays	*Blackboard* Posting	24×8
Post-test Administration	Dec. 2	In-Class Writing	24/Group
Questionnaire Administration	Dec. 4	In-Class Response	24/Group
Course Grade Available	Dec. 19	*Blackboard* Posting	24/Group

Notes: 24 = number of students in each class 8 = number of assignments
2 = number of reviewers per paper

Peer Review Process

Step 1: Filing draft. In the anonymous group, student authors posted their drafts (named *Fern* in this course) for each assignment on *Blackboard* for anonymous peer review on the due date, which both the instructor and the whole class had an access to. On the same day, each student would receive two Class ID numbers emailed to him/her by the instructor, indicating whose drafts he/she should review for this assignment. The email message went like this: "For assignment #1, you are supposed to review the drafts by 1221 and 2112". In order to provide students with opportunities to receive feedback from as many peers as possible to balance the uneven quality of feedback from different peers (Kerr et al., 1995; Robinson, 1999; Nilson, 2003), the instructor selected the reviewers for each assignment on a random-rotating basis. In the identifiable group, student authors posted their drafts on *Blackboard* (in their group page) for member peer review, which only the instructor and their group members had an access to.

Step 2: Reviewing drafts. In the anonymous group, students went to *Blackboard*, identified the two drafts by their assigned authors' Class ID numbers, downloaded them, and began reviewing them. In the identifiable group, students went to *Blackboard* (their group page), identified the two drafts posted by the other two members in their group (students in this group used their names in all *Blackboard* postings), downloaded them, and began reviewing them. Two types of editing were used on the drafts: 1) embedding editing — specific comments and suggestions about how to improve the paper were embedded in the draft; and 2) filing *Editor Worksheet* — after completing embedding editing, each student would file one *Editor Worksheet* on one draft he/she reviewed with suggested ratings (ranging from 1 – 15) for the overall quality of the paper, separate ratings (ranging from 1 - 4) for each dimension in the evaluating rubric (FOCUS EDIT), and detailed comments on the paper based on the FOCUS EDIT criteria. Both the edited draft and the *Editor Worksheet* were posted on *Blackboard* on the due date for revision.

Step 3: Revising drafts. Student authors revised their drafts based on the peer feedback and their own reflections, and produced the revised

paper (called *Coal* in this course). They were also required to file one *Author Response Sheet* for one peer editor, with suggested score (ranging from 1 – 15) for the overall quality of the feedback, and detailed comments assessing the usefulness of the feedback they received. Both the revised paper and the *Author Response Sheet* were posted on *Blackboard* on the due date for instructor review and grading.

Step 4: Grading papers. Student authors posted their revised papers and the *Author Response Sheet* on *Blackboard* on the due date. The instructor reviewed each paper as well as the feedback provided by the student in both *Editor Worksheet* and *Author Response Sheet,* and assigned a grade for the assignment based on the quality of these three products with the intention to motivate students' incentives in the peer review process so as to increase the accountability of peer feedback, as Nilson (2003) asserted that instructors could raise the quality of peer feedback by grading it. The grade for each assignment by the instructor also was available on *Blackboard.*

Data Analysis

To answer the first research question: "Does the use of anonymity in the e-peer review process result in better student writing performance", analysis of covariance (ANCOVA) were conducted to compare the writing scores for group differences. In this model, the covariate is the pre-test scores used to control for the initial group differences on student writing performance, the dependent variable is the posttest scores, and the independent variable (grouping variable) is the anonymous e-peer review versus identifiable e-peer review. ANCOVA is regarded as an especially useful technique in quasi-experimental design when it is not easy to randomly assign people to groups, and it can "subtract the influence of the relationship between the covariate and the dependent variable from the effect of one treatment" (Salkind, 2000, p 225). Students' overall course scores were compared using independent *t*-test with the student course scores as the dependent variable, and the grouping variable—anonymous e-peer review versus identifiable e-peer review as the independent variable. The first two hypotheses "Students in the anonymous e-peer review group will show greater improvement in their writing test scores than those in

the identifiable e-peer review group" and "Students in the anonymous e-peer review group will have higher course scores than those in the identifiable e-peer review group" were addressed by these analysis.

Regarding the second research question: "Do students in the anonymous e-peer review group have higher levels of perceived learning satisfaction than those in the identifiable e-peer review group", the statistical analysis of multivariate analysis of variance (MANOVA) was conducted to analyze the 4-point Likert scale questionnaire responses with anonymous e-peer review versus identifiable e-peer review as the two levels of the independent variable, and student satisfaction with the course (scores ranging from 10 to 40), student satisfaction with the assessment system (scores ranging from 12 to 48), and student satisfaction with the peer feedback (scores ranging from 11 to 44) as three levels of the dependent variable. MANOVA was chosen in the study instead of univariate analysis for each level of the dependent variable to avoid Type I errors. When significant differences were found, univariate analysis were conducted as follow ups to separately examine the effects of the independent variable on the three levels of the dependent variable to address hypotheses 3 (Students who give and receive e-peer feedback anonymously will have higher level of perceived satisfaction with the course than those who give and receive e-peer feedback identifiably), hypotheses 4 (Students who give and receive e-peer feedback anonymously will have higher level of perceived satisfaction with the assessment system than those who give and receive e-peer feedback identifiably), and hypotheses 5 (Students who give and receive e-peer feedback anonymously will have higher level of perceived satisfaction with peer feedback than those who give and receive e-peer feedback identifiably).

The statistical analysis of the demographic data was descriptive. Frequencies, percentages, means, standard deviation scores, and summary statistics were calculated and depicted using tables and graphs.

The responses to the five open-ended items in the questionnaire were examined with a qualitative approach to search for categories, themes and patterns appearing from these data (Patton, 2001). The qualitative approach was used as a complementary method in this study whose purposes were twofold: one was to augment and illuminate the

findings from the quantitative analysis, and the other was to discover new topics for future investigation and exploration.

In response to the third research question "Does anonymous e-peer review result in greater amount of critical feedback", MANOVA was conducted to compare 1) the number of negative comments on the reviewed drafts from the *Editor Worksheets*, and the *edited drafts* provided by the students in the two groups, and 2) the suggested rating on the overall quality of the reviewed drafts from the *Editor Worksheets* provided by the students in the two groups. The grouping variables, anonymous e-peer review versus identifiable e-peer review served as the two levels of the independent variable, and the number of negative peer comments and peer ratings were the two levels of the dependent variable. The results of the statistical analysis tested the last two hypotheses "There will be greater amount of critical peer feedback provided by students doing anonymous e-peer review than by those doing e-peer review identifiably," and "Students doing anonymous e-peer review tend to give lower scores on their peers' writings than those doing e-peer review identifiably".

CHAPTER IV

RESULTS OF THE STUDY

The purpose of this study was to investigate the effects of anonymous e-peer review on student writing performance, student learning satisfaction, and the amount of critical peer feedback. Data were collected from two intact classes at an urban public university during a span of 15-week semester using a quasi-experimental design. This chapter presents the results of the study by research question and hypothesis. Both descriptive and inferential statistics are reported in tables and accompanied with a narrative interpretation. Qualitative data are organized and presented according to the categories that emerged from the open-ended responses on the questionnaire. The demographic data are summarized in the first section to provide some background information of the sample involved in this study.

Sample Demographics

The demographic data of the sample were obtained from the self-reported questionnaires administered to all participants at the end of the experiment. A total of 48 freshmen ($n = 24$ in each group) participated in this study. Twenty-two students in the experimental group and 18 students in the control group submitted their completed questionnaires. Table 6 provides a summary of the sample's demographic characteristics.

Table 6

Demographic Characteristics by Group

Variables	Anonymous Group [a]			Identifiable Group [b]		
	N	M	SD	N	M	SD
Age	22	18.14	.56	18	18.28	.46
GPA (HS)	20	3.06	.40	18	3.03	.41
SAT	16	540	78.74	17	561	47.76

Variables		Anonymous Group [a]		Identifiable Group [b]	
		No.	%	No.	%
Gender	Female	13	59%	15	83%
	Male	9	41%	3	17%
Ethnicity	White	14	64%	9	50%
	Black	5	23%	6	33%
	Hispanic	2	9%	1	6%
	Other	1	4%	2	11%
Pre-Writing Training	Yes	5	23%	1	6%
	No	17	77%	15	94%
Registration Status	Full Time	22	100%	16	94%
	Part Time	0	0%	1	6%
Expected Course Grade	A	10	63%	7	50%
	B	5	31%	6	43%
	C	1	6%	1	7%
Why Taking the Course	Required	20	90%	16	88%
	Interest	1	5%	1	6%
	Instructor	1	5%	1	6%

[a] Two students did not respond to the survey
[b] Six students did not respond to the survey

The descriptive statistics presented in Table 6 revealed that the sample demographics were similar between the two groups across most of areas. A majority of respondents in each group were 18 or 19 years old; both groups were ethnically white dominated; all but one student registered as a full time student; about 90% of students in each group took this course because it was required. There were three demographic items related to students' prior academic achievements: high school GPA, SAT verbal scores, and expected course grade. Again, the two groups were very similar in terms of their mean scores on these variables. Whereas the average high school GPA of the anonymous group was a little higher (M = 3.06 vs. M = 3.03), the average SAT verbal score of the identifiable group was a bit higher

(M = 561 vs. M = 540). In light of expected course grade, there were a few more students in the anonymous group than in the identifiable group expecting to get an "A". There were only two areas in which the two groups differed to some extent—gender and pre-writing training experiences. Of the 20 students in the anonymous group, 13 (59%) were females and 9 (41%) were males, while in the identifiable group, 15 (83%) were females and 3 (17%) were males. Five students in the anonymous group and 1 student in the identifiable group had received certain types of writing training before the experiment.

Anonymity Manipulation Checks

In order to make sure that the treatment was implemented appropriately, two more close-ended questions were attached to the Learning Satisfaction Questionnaire administered to the students in the anonymous group, checking whether anonymity was observed as expected. The results were encouraging (See Table 7). The majority of students said that there was no possibility for them (77%) and their peers (72%) to identify specific comments from a specific editor.

Table 7
Results of Anonymity Manipulation Checks (N = 22)

Question: Were you able to identify specific comments from a specific editor?				
	Yes	Very Likely	Very Unlikely	No
N	2	3	13	4
%	9%	14%	59%	18%
Question: Were other members of your class able to identify specific comments from a specific editor?				
	Yes	Very Likely	Very Unlikely	No
N	3	3	12	4
%	14%	14%	54%	18%

Student Writing Performance

The first research question addressed whether the use of anonymity in the e-peer review process resulted in better student writing performance. The answer to this question relied on the data from two

sources: students' pretest and posttest essays scores, and students' overall course scores.

Student Pretest and Posttest Essay Scores

The major measures of student writing performance were student essay scores from the pretest that was administered before the treatment and the posttest that was administered at the end of the treatment. All participants in the study (N = 48) took both the tests. Using the pretest scores as the covariate, a one-way analysis of covariance (ANCOVA) was performed to assess differences in adjusted posttest mean scores between the anonymous group and the identifiable group. The independent variable was the grouping variable (anonymous peer review vs. identifiable peer review). The preliminary analysis evaluating the homogeneity-of-slope assumption indicated that the relationship between the covariate and the dependent variable did not differ significantly as a function of the independent variable, $F (1, 41) = .02$, MSE = .40, $p = .90$. Detailed ANCOVA results are presented in Table 8.

Table 8

Analysis of Covariance of Posttest Essay Scores as a Function of Treatment Condition with Pretest Essay Scores as Covariate

Source		Unadjusted Means	SD	Adjusted Means	SE	
Anonymous Group		3.09	.65	3.06	.13	
Identifiable Group		2.45	.67	2.48	.13	
Mean Difference		.64		.58		
Source	SS	df	MS	F	p	η^2
Covariate	2.55	1	2.55	6.59	.014*	.14
Posttest	3.69	1	3.69	9.54	.004**	.19

Note: * $p < .05$
** $p < .01$

As expected, the ANCOVA was significant, $F (1, 42) = 9.54$, MSE = .39, $p < .01$. The mean of the posttest scores adjusted for initial differences was 3.06 (out of 4) for the anonymous group with a standard error of .13, while the adjusted mean for the control group

was 2.48 with a standard error of .13, which was a good indicator that the experimental group performed significantly better than the control group on the posttest controlling for the pretest differences. These results support the first hypothesis that students in the anonymous e-peer review group will show greater improvement in their writing test scores than those in the identifiable e-peer review group, which suggests that the use of anonymity in e-peer review process does result in better student writing performance.

The descriptive statistics for the pretest and posttest essay scores shown in Table 9 and Figure 2 revealed that the anonymous group had substantially higher posttest scores. The mean difference between the pretest and posttest for the anonymous group was .66, while the mean difference was .17 for the control group. This result means that learning occurred between pretest and posttest for both groups; however, the students giving and receiving e-peer feedback identifiably did not make as much progress as those giving and receiving e-peer feedback anonymously.

Table 9

Descriptive Statistics for Pre- and Post-test Scores by Group

Source	Pretest			Posttest			Mean Difference
	N	M	SD	N	M	SD	
Anonymous Group	24	2.43	.66	23	3.09	.65	.66
Identifiable Group	24	2.27	.75	22	2.45	.67	.17
Mean Difference		.16			.64		.49

Figure 2. Comparison of the Pre- and Post-Test Mean Scores by Group

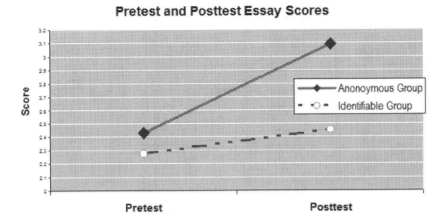

Pretest and Posttest Essay Scores

Student Overall Course Scores

Student overall course scores served as a supplementary measure for student writing performance. An independent *t*-test was performed to evaluate the second hypothesis that students in the anonymous e-peer review group would have higher course scores than those in the identifiable e-peer review group. Inconsistent with the results of ANCOVA on student pre- and post-test scores, the independent *t*-test on student overall course scores was not significant, t (46) = 1.49, p = .14. Table 10 provides the results from the *t*-test.

Table 10
Comparison of Student Overall Course Scores by Group

Source	N	M	SD	df	t	p
Anonymous Group	24	87.96	5.56	46	1.49	.14
Identifiable Group	24	84.42	10.20			
Mean Difference		3.54				

Despite the non-significant *t*-test results, it is worthy of note that the anonymous group on the average had a higher course score (M = 87.96, SD = 5.56) than the identifiable group (M = 84.41, SD

= 10.20). A graph of the comparison of the course scores between the two groups provided in Figure 3 illustrated this trend. Therefore, this unexpected result did not contradict the results obtained from the ANCOVA even though it failed to significantly support the second hypothesis.

Figure 3. Distributions of the Student Overall Course Scores by Group

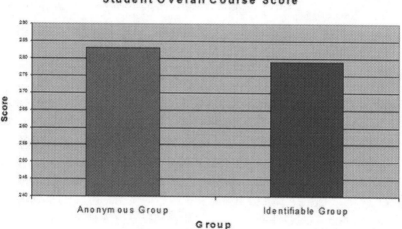

Student Learning Satisfaction

To answer the second research question "do students in the anonymous e-peer review group have higher levels of perceived learning satisfaction than those in the identifiable e-peer review group", scores on the Student Learning satisfaction Questionnaire were compared by group. As described in Chapter 3, the questionnaire included 33 items on a 4-point Likert scale and 5 open-ended questions. It was administered to all 48 participants in both groups immediately at the end of the treatment. Twenty-two students in the anonymous group and 18 students in the identifiable group completed the questionnaires. Student learning satisfaction was measured in three domains: student satisfaction with the courses, student satisfaction with the assessment system, and student satisfaction with peer feedback, serving respectively as three

dependent variables. Multivariate analysis of variance (MANOVA) was performed to determine the effects of anonymous e-peer review vs. identifiable e-peer review on the three dependent variables. The results of the statistical analysis are displayed in Table 11.

Table 11
MANOVA Results for Student Learning Satisfaction

Dependent Variables	MANOVA			
	df	F	p	η^2
Wilks's Lambda = .94	3, 36	.74	.54	.06
Satisfaction with Course	1	1.34	.25	.03
Satisfaction with Assessment System	1	.33	.57	.01
Satisfaction with Peer Feedback	1	.94	.83	.00

The MANOVA analysis indicates no significant difference between the two e-peer review conditions on all the three dependent measures, Wilks' Λ = .94, F (3, 36) = .74, p = .54. These results indicated that the use of anonymity in e-peer review process had no significant effects on student learning satisfaction. Therefore, the third hypothesis "students who give and receive e-peer feedback anonymously will have higher levels of perceived satisfaction with the course than those who give and receive e-peer feedback identifiably", the fourth hypothesis "students who give and receive e-peer feedback anonymously will have higher levels of perceived satisfaction with the assessment system than those who give and receive e-peer feedback identifiably", and the fifth hypothesis "students who give and receive e-peer feedback anonymously will have higher levels of perceived satisfaction with peer feedback than those who give and receive e-peer feedback identifiably", were not supported.

Although no significant differences were found on the three levels of student learning satisfaction based on the MANOVA results, the descriptive statistics displayed in Table 12 and Figure 4 showed that the students in the anonymous group were a little more satisfied with the course and the assessment system than the students in the identifiable group. The mean score of the satisfaction level with the course for the anonymous group was 32.86 (out of 40) with a standard deviation of 4.83, while the mean score for the identifiable group was 31.17 with a

standard deviation of 4.32. The mean score of the satisfaction level with the assessment system for the anonymous group was 36.64 (out of 48) with a standard deviation of 5.07, while the mean score for the identifiable group was 35.83 with a standard deviation of 3.45. The satisfaction levels with peer feedback were almost identical between the two groups with a slight difference of .30 in favor of the identifiable group.

Table 12

Descriptive Statistics on Student Learning Satisfaction with the Course, the Assessment System and Peer Feedback by Group

Dependent Variables	Anonymous Group			Identifiable Group			Mean Difference
	N	M	SD	N	M	SD	
Satisfaction with Course	22	32.86	4.83	18	31.17	4.32	1.69
Satisfaction with Assessment System	22	36.64	5.07	18	35.83	3.45	.81
Satisfaction with Peer Feedback	22	30.64	4.17	18	30.94	4.78	-.30

Figure 4. Distribution of Student Learning Satisfaction Levels

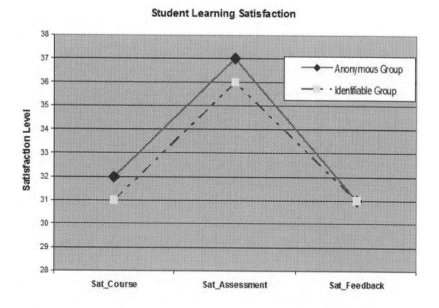

Critical Peer Feedback

The third research question asks whether anonymous e-peer review results in a greater amount of critical feedback. Two hypotheses were derived from this research question: "There will be a greater amount of critical peer feedback provided by students doing anonymous e-peer review than by those doing e-peer review identifiably", and "Students doing anonymous e-peer review will tend to give lower scores on their peers' writings than those doing e-peer review identifiably". The data used to test these two hypotheses came from the peer-reviewed drafts and peer-filed *Editor Worksheet*. Altogether 332 peer-reviewed drafts and editor worksheets (86% of the total required reviews) were obtained from the anonymous group, and 296 (77% of the total required reviews) from the identifiable group. The number of negative comments provided by peer reviewers in each reviewed draft and *Editor Worksheet* was counted and the peer ratings on the overall quality of the reviewed drafts provided in each *Editor Worksheet* were recorded for statistical analysis. A multivariate analysis of variance (MANOVA) was performed on the two dependent variables: the amount of critical peer feedback (measured by the number of negative peer comments), and peer mean ratings by group. The grouping variable (anonymous e-peer review vs. identifiable e-peer review) served as the independent variable. The MANOVA results are shown in Table 13.

Table 13

MANOVA Results for Peer Negative Comments and Peer Ratings

Dependent Variables	MANOVA			
	df	F	p	η^2
Wilks's Lambda = .93	2, 625	22.49	.00*	.07
Peer Negative Comments	1	37.15	.00*	.06
Peer Rating	1	7.75	.01*	.02

Note: * p < .01

The overall MANOVA revealed a significant difference between the two groups on the two dependent measures, Wilks' $\Lambda = .93$, F (2, 625) $= 22.49, p < .01$. Analyses of variance (ANOVAs) were conducted as follow-up tests to the significant MANOVA. The ANOVA on both dependent variables were significant, F (1, 626) $= 37.15, p < .01, \eta^2 = .06$ on the measures of the negative comments, and F (1, 626) $= 7.75, p < .01, \eta^2 = .02$ on the measures of peer rating. Therefore hypothesis six "there would be a greater amount of critical peer feedback provided by students doing anonymous e-peer review than by those doing e-peer review identifiably", and hypothesis seven "students doing anonymous e-peer review would tend to give lower scores on their peers' writings than those doing e-peer review identifiably" were confirmed by the data analysis.

The descriptive statistics illustrated these findings: the anonymous group did provide more negative comments for each reviewed draft (M = 5.37, SD = 4.15) than the identifiable group (M = 3.94, SD = 3.07), and the overall peer ratings of the anonymous group was lower (M = 11.36, SD = 2.32) than those of the control group (M = 11.82, SD = 1.81). These results suggested that students working in anonymous condition were more critical than those working in identifiable condition. Table 14 contains the means and the standard deviations on the two dependent variables for the two groups, and Figure 5 presents the distributions of the means of the amount of peer critical feedback and peer ratings.

Table 14

Descriptive Statistics for Peer Negative Comments and Peer Ratings by Group

	Negative Comments			Peer Rating		
Group	N	M	SD	N	M	SD
Anonymous Group	332	5.73	4.15	332	11.36	2.32
Identifiable Group	296	3.94	3.07	296	11.82	1.81
M. Difference		1.79			-.46	

Figure 5. Distributions of the Peer Negative Comments and Peer Ratings

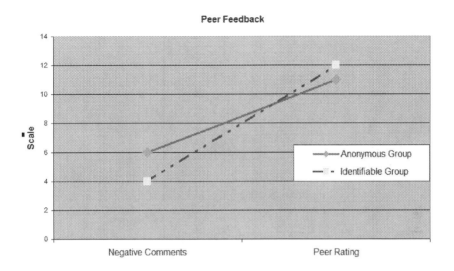

Qualitative Data Analysis

Five open-ended questions were included in the Student Learning Satisfaction Questionnaire, which was administered to all participants at the end of the treatment. Student responses to these questions were analyzed using qualitative approach, aiming to help explain the quantitative findings and understand in depth whether the use of anonymity in peer review had any impact on students' attitudes toward peer feedback and peer review system. On the basis of repeatedly reviewing the student responses, several categories emerged for each question. The results were tabulated and interpreted in subsequent paragraphs.

Student Perceptions of Peer Feedback and Peer Reviewers

One of the open-ended questions addressed student perceptions of their peers' ability in giving feedback. Both positive and negative comments emerged from students' responses. Table 15 presents a summary of the major categories related to the positive responses.

Table 15

Frequency and Percentage of Student Positive Responses to Peers' Ability in Giving Feedback by Category

Category	Anonymous Group N	Anonymous Group %	Identifiable Group N	Identifiable Group %
Good / Helpful / Useful	15	62%	11	74%
Honest	3	13%	2	13%
Responsible	3	13%	2	13%
Improved	2	8%	0	0%
Help think critically & analyze critically	1	4%	0	0%
Total	24	100%	15	100%

Table 15 contains five major categories emerging from students' positive responses to peer feedback and peer reviewers. Overall, there were more positive responses by the anonymous group (N = 24) than by the identifiable group (N = 15). The top category for both groups centered on the notion that peer feedback was perceived as "satisfactory" or "helpful" or "useful" (it accounts for 62% of the total positive responses by the anonymous group and 74% by the identifiable group).

There were a few students in both groups who showed their appreciation for the honesty and responsibility of their peers in giving feedback. Typical comments were: "Overall, I say it is positive because the peers didn't hold back" (anonymous group); "They didn't hide how they felt about my writing or my papers but did it in a way you wouldn't get your feelings hurt" (identifiable group); "Great—they went through the whole paper, added things needed and pointed out mistakes overlooked—they really put time and effort into editing" (anonymous group).

It is interesting to note that the positive responses from the anonymous group varied in content to certain extent: two more categories were identified from this group. Two students (8% of responses) claimed that their peers' feedback got better as the course progressed in the semester. One student (4%) believed that peer feedback empowered her/him with critical thinking ability. She/he commented:

I think their feedback was useful, helpful & effective. Even if sometimes I disagreed with their suggestions, it doesn't matter because that's what feedback is about--make you think critically & analyze your paper critically.

Although the positive responses were encouraging, there were also clearly negative student responses derived from the data, though not as many as the positive ones. Table 16 summarizes students' negative comments on peer feedback and peer reviewers.

Table 16

Frequency and Percentage of Student Negative Responses to Peers' Ability in Giving Feedback by Category

Category	Anonymous Group		Identifiable Group	
	N	%	N	%
Poor / Useless / Ambiguous	5	37%	2	14%
Not Correct / Not Appropriate	3	21%	2	14%
Lack of Editing Skills	3	21%	0	0%
Irresponsible	3	21%	4	28%
Not Honest	0	0%	2	14%
Not Open to Criticism	0	0%	1	8%
Lack of Cooperation	0	0%	3	21%
Total	14	100%	14	100%

Table 16 displays the categories associated with students' negative attitudes toward peer feedback and peer reviewers. Unlike the pattern observed for positive responses, disagreement was found in almost all categories between the both groups. First, the total number of negative comments identified from the two groups was equal. Given that there were fewer respondents from the identifiable group (N = 18 vs. N = 22) and that there were fewer positive comments from this group (N = 15 vs. N = 24), it seemed that the students in the identifiable group were somewhat less satisfied with their peers' ability in giving feedback. Second, it turned out that students in the anonymous group

were more bothered about the quality of peer feedback. Thirty-seven percent of responses in the anonymous group (vs. 14% of responses from the identifiable group) indicated that some of the peer comments were "poor, useless, vague, ambiguous, or redundant", and 21% of the responses (vs. 0% from the identifiable group) signified that their peers were "lack of editing skills". One student complained:

> Most of the feedback was good, but in some cases they might miss something big because it is something that they struggle on too, and also sometimes they would turn what I was trying to say into something different.

> Another student expressed his/her frustration:
> We are all at the same level, so sometimes it is hard to take feedback from someone at your level. I think many of them do not know how to give feedback and they didn't supply really any helpful information.

In contrast, more students in the identifiable group (N = 4; 28% of responses) complained about the irresponsibility of their peers in editing their papers. Some of the examples are:

> Sometimes it seemed like they were in a rush or didn't care about my paper. I even had a few papers go unedited. To be honest, one of my group members never really gave serious feedback.

> I don't think my peers put enough effort and criticism into giving feedback. There were many times where the feedback I received consisted of "Good job" and that was all.

> I think that overall the feedback I got from my peers seemed to be "rushed through". It didn't feel as though everyone took the time to make the best suggestions possible.

Noticeably, although there were three students (21% of responses) in the anonymous group who also expressed disappointment to the irresponsibility of their peers, these complaints all focused on their peers' failure in submitting reviewed work on time, such as, "some people didn't do their work on time which slowed down the review process"

In addition, a couple of students in the identifiable group expressed reluctance in sharing honest feedback with their peers and expressed their concern about their peers' reaction to the feedback. One student revealed, "It was a little harder to be honest if you didn't like something because some people tended to take constructive criticism too personally", and another student commented on the same issue from a receiver's point of view: "They had problems letting me know what was wrong. They were too nice".

Irresponsibility of some group members was another salient problem related to the identifiable group. Typical comments were as follows:

> One of my group members was good when she did the feedback and she always gave useful feedback and good examples, but the other one just stopped doing any work at all.

> The feedback that I received from my group members never helped me in writing my papers. I asked my mom and other members outside of my group for help and feedback.

Similar responses were found from both groups in one category. Three students (21% of responses) in the anonymous group and two (14% of responses) in the identifiable group thought that some of their peers' suggestions were not correct or appropriate. One student stated, "My peers' feedback was well thought through but sometimes I would not agree" (identifiable group). Another student put it in this way:

Sometimes the feedback would be ok, and other times the feedback would be nonsense or wrong. By wrong I mean that they would tell you to put a comma where one didn't belong to and things like that. (Anonymous Group)

Student Perceptions of Their own Ability in Giving Feedback

Students were asked to evaluate their own ability in giving feedback on their peers' papers. Table 17 presents the major positive categories emerging from their responses.

Table 17

Frequency and Percentage of Student Positive Responses to their Own Ability in Giving Feedback by Category

Category	Anonymous Group		Identifiable Group	
	N	%	N	%
Very Good / Very Helpful	6	20%	5	24%
Satisfactory / Useful / Informative	11	37%	9	42%
OK / Acceptable	2	7%	1	5%
Improved	2	7%	1	5%
Critical / Honest	4	13%	1	5%
Responsible	5	16%	4	19%
Total	30	100%	21	100%

Table 17 represents a comparison of student positive perceptions of their own ability in giving feedback between the two groups. Notice that a very similar pattern of responses was found between the anonymous group and the identifiable group. The majority of students in both groups thought that the feedback they gave to their peers was "very good" (it accounts for 20% of the positive responses by the anonymous group and 24% by the identifiable group), or "satisfactory" (37% by the anonymous group and 42% by the identifiable group). Some of the examples are: "On a scale from 1 to 10, I give it a 8" (anonymous group); "I found my feedback to be straight to the point and very helpful for the peer's paper" (anonymous group); "I tried hard to do a decent job. I think that I gave valuable feedback to my group

members" (identifiable group); "For what I was able to complete, I thought my feedback was fair and helpful" (identifiable group).

There were a couple of students in both groups who considered that the feedback they provided was "ok" and that their ability in giving feedback was "improved as the class went along". Furthermore, several students in each group (N = 5 vs. N = 4) claimed that they were responsible for editing their peers' papers and that they tried their best to help their peers.

Perhaps the only differences between the two groups were students' attitude toward giving critical and honest feedback. Four students (13% of responses) in the anonymous group reported that they were critical and straightforward in offering feedback while only one student in the identifiable group (5% of responses) shared this opinion. This result reinforced the findings from the quantitative analysis that students in the anonymous group were more critical in giving feedback than those in the identifiable group. Additionally, it is interesting to note that students tend to associate critical feedback with good feedback, for example:

> I attempted to be as critical as possible so that the author could make possible changes and improve their paper. I think I was good with giving feedback. (Anonymous Group)

> I believe I gave good feedback. I was straight forward and right to the point. If I felt like something could sound better, then I would just put forward my ideas and never hold them back. (Anonymous Group)

> I think I was as honest and effective as could be, and they seemed to appreciate my comments and used my suggestions. (Identifiable Group)

In addition to the above positive comments, students also expressed some concerns on their own ability in giving feedback. Table 18 presents summary results in the major categories of student negative perceptions.

Table 18

Frequency and Percentage of Student Negative Responses to their Own Ability in Giving Feedback by Category

Category	Anonymous Group		Identifiable Group	
	N	%	N	%
Not Confident in giving feedback	2	67%	3	37%
Irresponsible	1	33%	2	26%
Concern about the responses of reviewees	0	0%	3	37%
Total	3	100%	8	100%

It was somewhat surprising to discover that the identifiable group led in the number of comments in all three categories. Only three negative responses were observed from the anonymous group whereas eight were found from the identifiable group. Considering the fact that there were four more respondents in the anonymous group, this was especially a noteworthy difference.

Two students in the anonymous group and three in the identifiable group claimed that they were not confident in their ability in giving feedback:

> I guess I did a good job even though sometimes I wasn't sure whether my suggestions were right or wrong. At least I put them into some kind of thinking. (Anonymous Group)

> I basically did the same kind of things as the other students did. I felt like I was giving the same comments again and again, and sometimes I found myself having nothing to say. (Identifiable Group)

> Well, I'm not that good at editing papers. I did my best and tried to write clearly what I thought needed to be fixed. But sometimes it was hard for me to come up with new stuff or ideas to help my peers out. (Identifiable Group)

One student in the anonymous group and two in the identifiable group admitted that they sometimes felt "lazy" or "tired of" editing their peers' papers, and therefore, they "hastily wrote down whatever came to mind just to get it done by the deadline".

There is one point on which the two groups differed a bit. While three students (37% of responses) in the identifiable group were bothered about their peers' reactions to their feedback, no one in the anonymous group had such concern. One student stated, "Everything was pretty good, except it seemed one group member did not use it, or blamed me for her bad grade". Similar comments were made by another student: "At times, however, they tended to take constructive criticism too personally". Another student added, "I think that I gave valuable feedback to my group members, but I don't know if it was used as help or criticism." These findings supported the quantitative results indicating that students doing anonymous peer review provided a greater amount of critical feedback than those doing peer review identifiably.

Based on overall comparison of student attitude toward peer feedback and peers' ability in giving feedback with those of themselves, it is obvious that students were more satisfied with their work as reviewers (positive responses: $N = 51$, negative responses: $N = 11$) than that of their peers (positive responses: $N = 39$, negative responses: $N = 28$); students in the anonymous group provided more positive comments for both their peers and themselves ($N = 24$ and $N = 30$) than those in the identifiable group ($N = 15$ and $N = 21$); students in the identifiable group had more negative comments toward their own ability in giving feedback ($N = 8$) than those in the anonymous group ($N = 3$).

Student Perceptions of the Advantages of Peer Review

Another open-ended question asked students to name the advantages of peer review. This question produced seven types of responses (see Table 19).

Table 19
Advantages of Peer Review

Category	Anonymous Group		Identifiable Group	
	N	%	N	%
Get new, different and multiple insights and perspectives on papers	9	32%	12	41%
Help improve papers and thus help improve grade	7	25%	9	31%
Learn from peers' strong points as well as weakness	5	18%	4	14%
Feel more comfortable in giving honest feedback because of anonymity	4	14%	0	0%
Have flexible and convenient e-peer review system	2	7%	2	7%
Build friendship with peers	0	0%	2	7%
No advantages at all	1	4%	0	0%
Total	28	100%	29	100%

Table 19 lists seven major categories emerging from students' responses to the advantages of peer review. The most salient advantage repeatedly mentioned by students in both groups (N = 9; N = 12) was that peer review provided them opportunities to get new, different, and multiple insights on their papers. One said, "It gave you someone else's opinion on your paper other than yourself" (anonymous group). Others added, "The author is able to get different comments from different people which can lead to a improved paper" (anonymous group), and "With 2 people editing your paper, they can catch mistakes you have made and give suggestions about how to fix these mistakes and make the paper more interesting" (anonymous group). Similar comments were also found in the identifiable group, such as, "The advantages were I got to know what other people think of my paper and take advantage of their skills and perspectives"; "The advantage of peer review was showing us how other people may interpret our papers so that we can look at our own papers from a different angle"; "You get a lot of insight on how you write and you really do learn and get better from taking advice from your peers", etc.

Another advantage of peer review valued by students in both groups (N = 7 for the anonymous group; N = 9 for the identifiable group) was associated with the quality of their papers and their grade. Many believed that their peer editors helped improve their papers so that they could get better grade for the course. Some of the comments are:

> I would rather have a peer editor review my paper and catch my mistakes before turning it in to a professor. It gave me a chance to make my paper better before submitting it for a final grade. (Anonymous Group)

> If you aren't a good writer, then you can get help from your peers. They can see the mistakes you overlooked and they usually offer good suggestions that make your paper some better before it is graded by the professor. (Identifiable Group)

Five students (18% of responses) in the anonymous group and four (14% of responses) in the identifiable group reported that they learned a lot from their peers by giving and receiving feedback:

> I became more comfortable with my writing because I saw how others were writing. Also, it was helpful to see that others were making the same mistakes as I was and how to fix them. (Anonymous Group)

> I learned things I didn't know before—like the usage of contraction, run-on sentences, etc. By reading my peers' papers and peers' feedback, I learned not only through my own mistakes, but also through my peers' mistakes. (Anonymous Group)

> You get a lot of insight on how you write and you really do learn a lot from your peers and get better with your writing by taking their advice. Peers sometimes

are better and more comfortable editors! (Identifiable Group)

Two students (7% of responses) in each group proclaimed that they liked the flexibility and the convenience of electronic peer review system. According to one student: "It's marvelous that you could do it all in your comfortable home on your own schedule" (anonymous group). Another student responded, "I feel it was good because I don't have to worry about printing out papers and finding time to meet my group members" (identifiable group).

There was one category that was unique to the anonymous group. It dealt with the influence of using anonymity in peer review. Four students (14% of responses) in the anonymous group stated that they found it easier and more comfortable to give and get honest feedback under anonymous condition. They argued, "Anonymous peer review was good way to get honest opinions from everybody"; "Peers probably felt more comfortable giving their true feelings in their feedbacks"; "One of the advantage of anonymous peer review is: it is all anonymous so you do not feel pressure to edit the paper the way the author would want you to"; "The real advantage of peer review, as I see it, was not knowing who the editors were so that you didn't have to worry about authors' feelings on your feedback". These data lent support to the assumption of this study that people tended to be more honest and less stressed under anonymous condition so that more critical feedback could be obtained.

In contrast, two students in the identifiable group regarded the member peer review as desirable. One commented:

> I like to do peer review among group members. I felt more comfortable talking to them and finding out exactly how they thought of my paper. We became good friends and we were all free to share our ideas".

One student in the anonymous group viewed peer review as a complete failure. "No advantages at all" was his response to this question.

Student Perceptions of Disadvantages of Peer Review

Various disadvantages of peer review were reported by students in both groups. Generally speaking, the negative comments from the anonymous group were more centered on the quality of peer feedback and the responsibilities of peer reviewers, whereas the negative comments from the identifiable group were more scattered across several categories (Table 20).

Table 20
Disadvantages of Peer Review

Category	Anonymous Group		Identifiable Group	
	N	%	N	%
Peers are not qualified for editing papers	10	42%	4	18%
Some peers are not responsible	8	33%	6	27%
Feedback was rejected or misunderstood	3	13%	3	14%
Blackboard doesn't work efficiently	2	8%	2	9%
Feedback is not critical and objective	0	0%	3	14%
Group members don't cooperate	0	0%	2	9%
No disadvantages at all	1	4%	2	9%
Total	24	100%	22	100%

Table 20 reveals that the top category emerging from the negative responses in the anonymous group was related to peers' capability in giving feedback. Ten students (42% of responses) felt that their peers were not quite qualified for editing papers:

> Unlike a professor who knows what is incorrect, my peers based the review mostly on whether or not they liked the paper instead of fixing what was wrong. I'd rather have someone who has a degree in English to teach me how to write instead of someone that is on the same level I'm on.

Some people are weak in writing; they can't really give good reviews. Therefore, there is danger of accepting suggestions that are wrong. I write better than average and I don't care what their feelings toward my papers are. I am mature enough to handle criticism.

Similarly, four students (18% of responses) in the identifiable group also expressed such concern. One explained, "I don't think we are on the level of offering feedback without the instructor's feedback. We are still in the process of becoming good writers/editors". Another student was more direct: "Three bad people shouldn't be so judgmental"!

Peers' irresponsibility in editing was another top category that was repeatedly mentioned by students in both groups. Eight students (33% of responses) in the anonymous group and six (27% of responses in the identifiable group) criticized their peers for either not being serious with editing or failing to edit papers on a timely fashion. One student pointed out, "Some peers didn't take the editing process seriously. They just changed 3 words and wrote 2 sentences about my paper, and that was all the editing" (identifiable group). One student was somewhat furious: "They were lazy, late, or wouldn't even do it! This was really irritating. I can't rely on their feedback at all" (identifiable group). A few students blamed their peers for the late works: "You could get a person who slacked on editing, which made things harder on you" (anonymous group).

Three students in each group mentioned peers' reactions toward feedback. They sensed that sometimes peer authors would "get upset and take offense to the editors' feedback", and at other times their comments "were not welcome" or "taken as criticism". But it is worthy to note that even though three such comments were found from each group, students in the identifiable group showed a stronger sense of worry on this topic than those in the anonymous group. One student in the identifiable group wrote, "Peer review is pretty good, except it seemed one group member did not use my feedback, and often blamed me for her bad grade". Another student exclaimed, "They might completely tear your paper up and that makes you feel

very bad". In contrast, students in the anonymous group approached this problem from a different angle: "Sometimes an author would take offense to the editor's feedback, so it was nice that we did peer review anonymously". These data once again strengthen the argument that people in anonymous condition feel less pressure in giving feedback.

Two more categories emerged from the responses of the identifiable group—one was associated with the critical nature of peer feedback, and the other with group procedure. Three students (14% of responses) viewed the feedback they received from their group members as "less critical" or "less objective". Comments included: "Some people including myself weren't quite critical of another's paper"; "When you know each other, you tend to be less critical"; "I don't think people are objective in reviewing peers' papers—personal feelings often get involved". This type of responses once again lent support to the third research question of this study—anonymous peer review results in more critical feedback.

Problems with group dynamics were once again touched upon as one of the disadvantages of the peer review system by the identifiable group. Two students (9% of responses) expressed their dissatisfaction with the lack of cooperation among group members.

Another category involved the usage of online resource. A couple of students in each group ascribed the drawbacks of the peer review system to the inefficiency of the "feedback carrier"—*Blackboard*. One student was irritated: "*Blackboard* was not functioning correctly a lot of times" (anonymous group)! Another student remarked:

> I believed that my ability in giving feedback was satisfactory. I think that it was somewhat hindered by the frustration I developed due to the Blackboard posting procedure. It was complicated and sometimes just didn't work appropriately. (Anonymous Group)

There was one student in the anonymous group and two (9% of responses) in the identifiable group who showed strong preference to peer review. "I don't think there are any disadvantage with peer review" was his or her point of view.

Improvement of Peer Review System

The final open-ended question asked students to suggest how to improve the peer review system. Seven categories were identified from the responses. The top category for both groups was accountability followed by training. See Table 21 for details.

Table 21

Suggestions for the Improvement of Peer Review System

Category	Anonymous Group		Identifiable Group	
	N	%	N	%
Increase student accountability	10	48%	9	45%
Provide more training on editing skills	5	24%	3	15%
It is good. No need for improvement	3	14%	2	10%
Select a better online peer review system	2	9%	2	10%
Use identifiable peer review	1	5%	0	0%
Use anonymous peer review	0	0%	2	10%
Have more interaction and communication among groups members	0	0%	2	10%
Total	21	100%	20	100%

Both groups strongly believed that peer review system would not work unless students take responsibility for doing it. Two themes appeared under this category—punish late work harshly, and grade the efforts of peer reviewers immediately. A good many students claimed that the peer review system would have worked more smoothly and produced better results if their peers could have been more serious about editing papers and providing timely feedback. Typical comments were: "They need to be on time, and they need to be serious"; "Have

severe consequences for turning in late work"; "Give immediate grade to peer feedback". One student suggested:

> If everyone turns in feedback on time, that will be a wonderful improvement. Stress how the grade will be extremely lowered when turning in late work. Other than that, I really love the peer review process. (Anonymous Group)

Another student proposed:

> Harsher consequences should be given to those who slack it! Make people turn in their feedback on time! The whole system should work like a well-oiled machine! Also, grade peer feedback timely so that they would put more efforts in editing papers. (Identifiable Group)

The second biggest concern of the students for peer review was the quality of peer feedback. Five students in the anonymous group (24% of responses) and three in the identifiable group (15 % of responses) recommended that more training on editing skills should be provided to help them provide quality feedback. It was suggested that more explanations be given in terms of the editing criteria, more examples be offered to illustrate how to edit papers, and more in-class practice be organized to guide them step-by-step in reviewing others' papers.

Three students in the anonymous group (14% of responses) and two in the identifiable group (10% of responses) enjoyed the peer review system per se: "The peer review system is fine as it is and shouldn't be changed" (anonymous group); "I like it how it is. It's well organized now" (anonymous group); "I think it's fine the way it is" (identifiable group).

Two students in each group proposed to choose a better online program to organize peer review system. They hoped that a less complicated and more efficient online tool could be used to conduct peer review:

I'm not sure if *"BlackBoard"* is the best way to go. It was not efficient. If there were a way to make *"BlackBoard"* more efficient or find a better program to do peer review, it would be great (the posting was the problem, not editing papers on the computer).

In light of different treatment condition, one student in the anonymous group stated that he/she would like to know who were the editors, and on the contrary, two students in the identifiable group expressed their preferences to anonymous peer review: "Anonymous peer review is a better technique"; "I guess many problems could be solved if we used anonymous peer review or we were able to choose our own partners".

Two students (10% of responses) in the identifiable group advocated that there should be more communication and interaction among group members so that they could know one another better and share their ideas more efficiently.

Summary

In this chapter, findings relative to the research questions and hypotheses were presented. Seven hypotheses developed from the three research questions in this study. They are: 1) Students in the anonymous e-peer review group will show greater improvement in their writing test scores than those in the identifiable e-peer review group, 2) Students in the anonymous e-peer review group will have higher course scores than those in the identifiable e-peer review group, 3) Students who give and receive e-peer feedback anonymously will have higher level of perceived satisfaction with the course than those who give and receive e-peer feedback identifiably, 4) Students who give and receive e-peer feedback anonymously will have higher level of perceived satisfaction with the assessment system than those who give and receive e-peer feedback identifiably, 5) Students who give and receive e-peer feedback anonymously will have higher level of perceived satisfaction with peer feedback than those who give and receive e-peer feedback identifiably, 6) There will be greater amount

of critical peer feedback provided by students doing anonymous e-peer review than by those doing e-peer review identifiably, and 7) Students doing anonymous e-peer review tend to give lower scores on their peers' writings than those doing e-peer review identifiably. The statistical analysis for the first hypothesis yielded significant differences, which indicated that students in the anonymous e-peer review group made a greater progress in their writing skills than their counterparts in the identifiable e-peer review group between pretest and posttest. Regarding the second hypothesis, although no statistically significant effects were revealed, the descriptive statistics showed that on average the anonymous e-peer review group had higher course scores than the identifiable group. Hypotheses 3, 4, and 5 were developed to evaluate whether differences existed between the two groups in terms of student satisfaction with the course, the assessment system and peer feedback. Again no statistical differences were found on any of the three dependent variables, which means that the use of anonymity in e-peer review process did not have a significant impact on student learning satisfaction. Hypotheses 6 and 7 intended to determine whether there were significant differences between the two groups on the amount of critical peer feedback and peer ratings. Both hypotheses were supported by the results: students in the anonymous group did provide more negative comments on peers' papers, and students in the identifiable group did give higher scores to peers' papers. Table 22 displays a summary of the statistical results of this study.

Table 22

Summary of the Results of the Statistic Analysis Corresponding to the Hypotheses

Hypotheses	Results	Direction
1. Students in the anonymous e-peer review group will show greater improvement in their writing test scores than those in the identifiable e-peer review group.	Significant	Anonymous > Identifiable
2. Students in the anonymous e-peer review group will have higher course scores than those in the identifiable e-peer review group.	Non-significant	
3. Students who give and receive e-peer feedback anonymously will have higher level of perceived satisfaction with the course than those who give and receive e-peer feedback identifiably.	Non-significant	
4. Students who give and receive e-peer feedback anonymously will have higher level of perceived satisfaction with the assessment system than those who give and receive e-peer feedback identifiably.	Non-significant	
5. Students who give and receive e-peer feedback anonymously will have higher level of perceived satisfaction with peer feedback than those who give and receive e-peer feedback identifiably	Non-significant	
6. There will be greater amount of critical peer feedback provided by students doing anonymous e-peer review than by those doing e-peer review identifiably.	Significant	Anonymous > Identifiable
7. Students doing anonymous e-peer review tend to give lower scores on their peers' writings than those doing e-peer review identifiably.	Significant	Anonymous < Identifiable

In conclusion, the findings from the quantitative data analyses suggest that anonymous e-peer review is related more to student learning outcomes and the nature of peer feedback than to learner perceptions. Namely, the use of anonymity in e-peer review process resulted in better student writing performance and greater amount of critical peer feedback, but has little impact on student learning satisfaction.

The main findings from the qualitative analyses can be summarized as follows: 1) students in both groups agreed that peer review offered

them opportunities to have different and multiple ideas on their papers which helped them write better and thus help improve their papers; 2) students in both groups felt that their ability in giving feedback was improved as a result of involvements in the peer review process; 3) feedback quality and peer accountability were two biggest concerns for the students in both groups, but it seems that students in anonymous group were more bothered by feedback quality while the students in the identifiable group had more complains about peer irresponsibility; 4) two salient pitfalls with the peer review system were noted by the identifiable group: students in this group found it difficult to get and give critical feedback for fear of negative peer reaction, and students in this group were not satisfied with the group mechanism; 5) students in both groups suggested that more training on editing skills should be given so as to guarantee quality feedback, and measures should be taken to increase student accountability in doing peer review.

CHAPTER V

DISCUSSION AND RECOMMENDATIONS

Peer review has been used in writing instruction for several decades, and it has been found beneficial to student learning. With the ever-increasing popularity of electronic communication, anonymous e-peer review has begun to draw attention from researchers and educators. This study examined the effects of anonymous e-peer review on student writing performance, student learning satisfaction, and the amount of critical peer feedback using a quasi-experimental design. The problem statement, literature review, research design, and experimental results were presented in previous chapters. This chapter includes the discussion of the research findings, followed by the limitations of the study and the strategies to minimize them. The practical implications for educators and suggestions for future research compose another major section.

Discussion

Anonymous e-Peer Review and Student Writing Performance

The treatment in this study—using anonymous e-peer review in writing instruction—was targeted at improving student academic achievement. Therefore, the first research question centered on the effectiveness of anonymous e-peer review on student writing performance. The major measure of this assessment was student essay scores on the pretest and posttest. The results of the data analysis (ANCOVA) indicated that the students in the anonymous e-peer review group performed significantly better than those in the identifiable group ($F = 9.54$, $p <$.01). These results concur with the findings of some previous studies (Haaga, 1993; Guilford, 2001; Pelaez, 2002; Tuautmann et al., 2003). Guilford applied anonymous peer review for teaching undergraduate students the full scientific publishing process during the process of writing a term paper. At the end of the semester, students were asked to numerically score their agreement or disagreement with several

statements about their experiences with this anonymous peer review process. The survey results indicated that students strongly agreed that their course grades and the quality of their papers improved as a result of this teaching method. Pelaez designed a study comparing the effects of two instructional approaches—problem-based writing with anonymous peer review (PW-PR) vs. traditional didactic lectures followed by group work (traditional instruction)—on student performance on physiology exams. Based on the results of statistical analysis, Pelaez concluded that students really learned better with the problem-based writing with anonymous peer review. A pilot study of multi-university peer review by Tuautmann and her associates involved 400 students from 11 colleges and universities doing double-blind online peer review. Students were surveyed at the end of the course and they reported that the peer review process gave them insights into their own work and helped them to improve their writing and critical thinking skills. An earlier study by Haaga who used anonymous peer review in his three graduate courses also suggested that anonymous peer review was an effective strategy in helping students with their papers. These finding further illustrated that anonymous peer review invites more honest, accurate, and critical feedback which is valuable in helping improve students' writing skills (Zhu, 1995; Schulz, 1996; Bostock, 2000).

Even though students in the anonymous group showed significantly larger gains in writing performance than the identifiable group, the descriptive statistics revealed that both groups improved their writing scores from pretest to posttest (Mpre = 2.43, Mpost = 3.09 for the anonymous group; Mpre = 2.27, Mpost = 2.45 for the identifiable group), which implies that peer review enhances student writing skills regardless of the delivery mode of peer feedback. This result expanded the literature on peer review and peer evaluation reporting that peer feedback was often associated with better student writing skills and learning gains. Ramsden (1992) found from his dissertation study that students could often learn more from formal or informal assessment by their peers, which made it unnecessary for instructors to spend much time on evaluating work. Richer (1992) compared the effects of peer directed feedback with teacher based feedback on first year college students' writing proficiency, and the results shown that greater

gains in writing proficiency was obtained by the peer feedback group. A related study by Chaudron (1983) yielded similar results. Chaudron compared the effects of teacher feedback, ESL feedback, and peer feedback from native English speakers on student writing products. The assessment of revised compositions indicated that students in all three-feedback conditions demonstrated improvement from draft to revision. Liu et al. (2001) compared students' assignment scores which were achieved by students under peer review with the final scores which were gained by students alone. The paired t-test revealed that students performed better with peer review. The research on classroom peer review process conducted by Liu et al. (2002) showed that both reviewers and reviewees benefited from peer review in terms of their completed term projects. Catterall (as cited in Topping, 1998) had short essay tests peer marked by students. Learning gains from peer assessment were reported by 88% of participants. On the basis of a meta-analysis of the studies on peer assessment at tertiary level, Topping (1998) concluded that peer assessment of writing had positive formative effects on student achievement, and that these effects were as good as or better than the effects of teacher assessment.

As well, this finding seemed plausible for the research on electronic peer review. Lin and his associates (Lin et al. 1999; & Lin et al. 2001) conducted a series of studies on Web-based peer review and the results illustrated that Web-based peer review was closely related with student achievement. Tannacito (2001) pronounced after analyzing his students' comments in the online asynchronous discussions and in their email messages, that quality of the students' revisions improved with the peer review process. Brock (1993) compared feedback from computerized text analysis programs and from peer assessment and tutoring for 48 ESL student writers in Hong Kong. Both groups showed significant growth in writing performance. Building upon the research findings of these and other relevant studies, the current study adds to the literature that another kind of peer review strategy, anonymous e-peer review, also leads to the improvement in student writing performance.

A supplementary measure of student writing performance in this study was student overall course scores. The t-test comparing the mean difference of student course scores between the anonymous group

and the identifiable group was not statistically significant at the .05 level (t = 1.49, p = .14). There are several explanations for the small treatment difference on the courses scores between the two groups. One plausible explanation could be the "instructor effects": the instructor might intentionally avoid extremely low scores so as not to discourage student learning, and also it was likely that the instructor might take other factors into consideration when grading student papers, such as, student attendance, student in-class performance, student course grade balance, etc. Another explanation could be attributed to the limitation stemming from the use of student overall course scores (course grade) as a measure of writing performance. Woodward and Sherwood (1980) suggested that using grades to assess performance is more like using performance appraisal results rather than using hard productivity data to evaluate outcomes. Compared with the pre- and post-test writing measurement, it is obviously a less rigorous measurement. Furthermore, in spite of the non-significant difference, the mean course score of the anonymous group was higher than that of the identifiable (M = 87.96 vs. M = 84.41). Therefore, these findings suggest that anonymous e-peer review is effective in achieving the intended goal: improving student writing skills. The first research question thus was answered: the use of anonymity in the e-peer review process does result in better student writing performance.

Anonymous e-Peer Review and Student Learning Satisfaction

The second research question explored whether the anonymous e-peer review would lead to higher levels of student learning satisfaction. A post treatment survey administered immediately after the implementation of the treatment served as a measurement. Both quantitative and qualitative data were gathered from the survey.

Quantitative findings. To determine students' attitudes toward their learning experiences in the course, participants in both groups were asked to respond to a questionnaire specifically developed to gather their satisfaction with the course, the assessment system, and peer feedback. The MANOVA yielded a non-significant difference. Specifically, the data did not support the expectation that students doing e-peer review anonymously were more satisfied with the course,

the assessment system, and peer feedback than those who did e-peer review in an identifiable condition. These results did not support the research hypotheses that predicted that anonymous e-peer review would lead to higher levels of student learning satisfaction as a result of improved writing performance and relief of social pressure in giving feedback, which implied that better academic achievement might not necessarily be related to higher levels of satisfaction. The results failed to provide empirical evidence to the assertion of some researchers and instructors that anonymous peer review is better received by students: 76% of the students in MacLeod' (1999) business communication classes expressed their strong favor for anonymous peer review in a survey; in Robinson's (1998) case, students showed an overwhelming preference for the anonymous peer review system. These findings are also incongruent with the empirical study by Lin et al. (2001) who administered a posttest questionnaire survey to computer science undergraduate students, evaluating student attitudes toward a Networked Peer Assessment System implemented for two-way anonymous peer assessment. The data from the survey revealed that significantly more students favored this networked anonymous peer assessment system, and that students with positive attitude outperformed those with negative attitude.

There are several reasons that may explain the lack of support for the hypotheses. One possibility for the non-significant results may have been related to the validity of the instrument. The Student Learning Satisfaction Questionnaire was pilot tested with 110 undergraduate freshmen who enrolled in an Education Curriculum and Instruction course (ECI 301), but the target population of the study is undergraduate freshmen enrolled in English Composition classes (Engl 110c). The dissimilarity between the pilot-test sample and the experimental sample may be a limitation that may have contributed to the lack of significant findings in the investigation.

Another factor that should be considered in interpreting the non-significant results of student learning satisfaction may be the small sample size (N = 24 in each group). As a questionnaire measurement, a larger sample might be needed to detect the effect. The insufficient respondents might have masked the treatment effect, and thus produced no differences by the treatment group.

Yet it is worth mentioning that even though no significant differences in student satisfaction were found between the two groups, the mean scores of the satisfaction levels for the anonymous group were slightly higher than those for the identifiable (M = 32.86 vs. M = 31.17 with course satisfaction; M = 36.64 vs. M = 35.83 with assessment satisfaction). Considering this feature and the possible factors contributing to the non-significant statistics described above, it is premature to declare that the use of anonymity in e-peer review process does not have any influence on student learning satisfaction.

Qualitative findings. Student responses to the 5 open-ended questions in the Student Learning Satisfaction Questionnaire comprised the qualitative portion of the study. While this study did not find statistically significance differences on student learning satisfaction between the anonymous group and the identifiable group from the quantitative analysis of the data, there is good information from the limited qualitative data gathered to help explain and extend the quantitative findings.

Several major themes were identified as contributors to both positive and negative attitudes. For both groups, the most overwhelming major theme associated with positive attitudes towards peer review was that peer review provided them opportunities to get new, different and multiple insights and perspectives on their papers which helped improve their papers and grade. Many participants concurred with the statements, such as, "You get a lot of insights on how you write and you really do learn and get better with your writing from taking advice from your peers"; "The author is able to get different comments from different people which can lead to an improved paper". Many students commented that by doing peer review they learned not only from their own mistakes but also from their peers' weakness as well as strength, which made them more confident in their assessment skills. This result provides empirical support to the arguments of many researchers, who assert that the use of peer review offers the learners the experience of seeing multiple opinions, which gives them greater confidence in the validity of the comments (Bhalerao & Ward, 2000; Nilson, 2003). Mangelsdorf (1992) posited that peer review helped most of his composition students "to see different perspectives about

their topics and to generate, clarify, and develop their ideas" (p. 281). This result also supports the learning theory of collaborativism and social constructivism whose basic premise is that learning requires exchanging and sharing of knowledge among learners (Asberg & Nulden; Liu et al., 2001).

For students in both groups peer review was considered a positive learning experience. A good many students (N = 15 in the anonymous group, and N = 11 in the identifiable group) perceived peer feedback as "good", "helpful", or "useful". Similar results were recorded by Liu, Pysarchik and Taylor (2002). Liu and his colleagues used peer review with both undergraduate and graduate classes for three academic years, students' comments on the peer review process gathered from either the university's official evaluation forms or class discussion sessions were generally positive. As well, the ESL writing students in Mangelsdorf's (1992) study found peer review beneficial. They commented that peer review had helped them revise the content of their drafts.

A comparative analysis of participant responses to the open-ended questions revealed that the implementation of anonymous e-peer review in writing instruction produced more positive attitudinal outcomes. Overall, students in the anonymous e-peer review group had more positive comments for both their peer reviewers and themselves as reviewers (N = 24 and N = 30) than those in the identifiable group (N = 15 and N = 21). This result mirrors the corresponding descriptive statistics obtained from the quantitative analysis, showing that the students in the anonymous e-peer review group had higher levels of satisfaction with the course and the assessment system even though no significant difference was found. Yet, it is incongruent with the studies by Connolly, et al. (1990), and Valacick et al. (1992), which indicated that small-identifiable groups had less conflict and were more satisfied with group effectiveness because of close and personalized interaction among group members.

While most students felt that peer review was helpful in improving their papers, concerns were raised on the apparent lack of responsibility displayed by some students.

Despite the findings from numerous studies suggesting that anonymity tended to produce social loafing among participants (Kerr & Bruun,

1981; William et al., 1981; & Zhao, 1998), the analysis of student responses in this study revealed that students in both groups blamed their peers for not being serious with the reviewing work. Two factors may attribute to this result. First, even though the students in the anonymous e-peer review group were anonymous to their peers, they were identifiable to the instructor and were subject to the evaluation by the instructor. As William et al. asserted, they might have experienced evaluation apprehension that would motivate them to exert greater effort to satisfy the instructor's expectations. The current study was successful in deterring more social loafing in the anonymous group by making anonymity "present" among students but "absent" to the instructor—the grader. Second, the teaching assistant's dereliction of duty might be part of the reason that accounted for such students' complaints. According to the original research design, the teaching assistant should review both revised papers and peer feedback immediately after they were posted on *Blackboard* with the intentions to guide students in giving meaningful feedback as well as to increase students' accountability in doing peer review. Unfortunately, because of some unexpected reasons, the teaching assistant did not review and grade students' work in a timely fashion. As a result, delayed and careless peer editing often occurred. Surprisingly, the students in the identifiable group seemed to be more frustrated by their peers' irresponsibility and procrastination in the peer review process which was contradictory to the "social loafing" theory. They used words as "lazy", "slack", or "they don't care" to describe their peers' attitudes toward editing. Here, anonymity actually helped prevent rather than caused the kind of "social loafing": throughout the semester, the students in the anonymous group would contact the teaching assistant whenever there is a problem in the peer review process to press for solution, while the students in the identifiable group just kept silent when facing such situation in order to keep harmonious interpersonal relationship among group members. Such phenomenon echoes what was reported by Carson and Nelson (1996), who investigated Chinese students' interaction styles and reactions to peer response groups in ESL composition classes. The data analyses of the videotapes and interviews in Carson and Nelson's study indicated that the Chinese students' primary goal for the groups was to maintain group harmony

and they were very careful not to precipitate conflict within the groups, which was also observed in the current study.

A "trust issue" was also frequently cited as a factor relating to student disliking of peer review. Many students suspected that their peers were not qualified for editing papers, and a few pointed out directly that some of the peer comments were "poor, useless, vague, ambiguous, redundant, or even incorrect". These remarks well resonated the claims by Quible (1997) that students often hesitate to take their peers' feedback seriously as they do not trust the value and accuracy of peer feedback. Similarly, in Mangelsdorf's (1992) study, the largest number of student negative thoughts about peer review dealt with students' lack of trust in their peers' feedback. A related concern was also noted from students' responses: several students expressed a lack of confidence in their own ability in giving feedback. Accordingly, many students proposed that more training on editing skills is needed when implementing peer review.

One puzzling finding warrants attention: it turned out that the students in the anonymous group were more bothered by the quality of peers' feedback (N = 10 vs. N = 4 for the identifiable group). This result echoes the corresponding finding from the quantitative analysis that the anonymous group was a little less satisfied with peer feedback (M = 30.64 vs. 30.94 for the identifiable group). It is not clear why anonymity caused less student satisfaction with peer feedback while led to more student satisfaction with the course and the peer review system.

Two themes that were of particular interest to the identifiable group were "group dysfunction" and "lack of critical peer feedback". Some students repeatedly expressed their resentment toward the lack of cooperation among group members. After reexamining the peer postings on *Blackboard*, the researcher found that three groups (out of eight) failed to carry out peer review appropriately. According to the course requirements, each student should review 16 drafts of their peers throughout the semester (2 drafts per assignment). Unfortunately, one student in one group only reviewed four drafts from two assignments. She received an "Incomplete" for this course. Two students in the other two groups completed about half of the required reviewing work. That is why there were fewer reviewed drafts

and Editor Worksheets from the identifiable group (N = 296 vs. N = 332 from the anonymous group). Such a phenomenon echoes the Dyrud's (2001) observation that some students developed a phobia about group work because of the lack of cooperation and accountability among group members. Falchikov (1995) also noticed through a series of studies on peer review and peer assessment that students were not willing to accept any responsibility for assessing their peer, especially in a small socially cohesive group or if they see it as substitutional. Here again, anonymity may have played a role in forcing the task done. As described earlier, students in the anonymous group would always email the teaching assistant when their assigned peers failed to post drafts or feedback on *Blackboard* on time, asking the teaching assistant to push them to submit their work as soon as possible. On the contrary, none of the students in the identifiable group emailed or talked to the teaching assistant about such problems. As a result, delayed or missed reviews occurred from time to time. To them, creating disharmony in a group could be a serious consequence. As noted by Carson and Nelson (1996), in group interaction, students were more interested in maintaining positive group relations rather than in helping each other with their writing, and they would rather sacrifice honesty for group harmony. Concomitantly, in this study students seemed to sacrifice their own learning interest to avoid conflict among group members.

Another salient finding from the qualitative data is that students in the identifiable group showed reluctance in offering critical feedback and expressed their worries about peers' reaction to their feedback. They felt it hard to "give somebody negative comments when you know him". Likewise, a few students claimed that the peer feedback they received was "less critical", "less objective", "less honest", and "less straightforward". This is consistent with the literature that suggests that student peer feedback is basically complementary and uncritical because students often experience a kind of "social pressure" in sharing critical feedback and they tend to overrate one another for fear of damaging personal relationships or being embarrassed (Mangelsdorf, 1992; Campbell & Zhao, 1996; Zhao, 1998; Lindblom-Ylanne & Pihlajamaki, 2003). The findings from a qualitative study by Lindblom-Ylanne and Pihlajamaki, who used peer review in a computer-supported learning environment with law students, showed

that sharing unfinished essays was too threatening and required too much openness for many students. Campbell and Zhao had two groups of pre-service teachers post their journals to a mailing list and then read and comment on each other's journals. It turned out that most of the peer comments were superficial and affirming, and very few were of critical nature. Campbell and Zhao thus concluded that students were more willing to compliment than challenge their peers because they might be afraid of hurting others' feelings or being rejected. The ESL writing students in Mangelsdorf's study reported that most of the feedback they received from their peers was not critical enough so that not much help could be obtained from such reviews. Zhao also claimed that students often felt very uncomfortable when asked to provide critical feedback to their classmates.

One unexpected finding from the qualitative data was that the students in the identifiable group had more negative comments on the feedback they provided for their peers ($N = 8$ vs. $N = 3$), whereas the students in the anonymous group had more positive comments on the feedback they gave to their peers ($N = 30$ vs. $N = 21$). This finding may challenge the assumption that students who take a critical approach when reading and scoring peers' essays are likely to be more critical of their own work (Kerr et al., 1995; Zhao, 1998). This contradictory finding may have the potential for further investigation.

In summary, the qualitative data obtained from this study lent strong support to the argument that emotion (concerns about peer reaction and interpersonal relationship), ignorance (lack of necessary editing skills), and irresponsibility (lazy, not serious) are three of the most formidable barriers in peer review and peer evaluation (Nilson, 2003).

It should be noted that even though the students' responses provided some useful information on peer review, because only limited amount of qualitative data were gathered, this exploratory effort might not have been a particularly strong test of student learning satisfaction with anonymous e-peer review.

Anonymous e-Peer Review and Critical Peer Feedback

The third research question intended to provide quantitative evidence to support the largely anecdotal exclamations and qualitative findings of previous studies that anonymous peer review overcomes the "halo error" phenomenon and leads to more critical peer feedback as a result of deindividuation caused by anonymity. Significant differences were found between the anonymous group and the identifiable group, which indicated that anonymous e-peer review did produce a greater amount of critical peer feedback and lower peer ratings. The results were consistent with the assertions and findings of the majority of studies in this area.

According to the literature, the predominant advantage of anonymous peer review is that it provokes more critical feedback. Studies have implied that in anonymous condition, people are more honest and less anxious in expressing their opinions because the removal of one's identity minimizes the restraining effects of the fear of being wrong or creating conflict. Zhao (1998) conducted two studies with college students exploring the effects of anonymity on peer feedback, in which students were asked to review journal entries of their peers in either anonymous or identifiable condition. The findings suggested that the reviews provided in the anonymous condition were more critical than those made in the identifiable condition. The work by Valacich et al. (1992) further confirmed this finding. Their experiment tested the effects of group size and group member anonymity on group idea generation. The data demonstrated that anonymous group members were more critical than identified group members, and members of large groups were more critical than members of small groups. Similar finding was reported by Connally et al. (1990), which found that anonymous groups generated more unique critical ideas and more overall comments than nonanonymous groups. Along the same line, Jessup and his colleagues (1988) administered three laboratory experiments to investigate the effects of anonymity on group process and outcome. The results from all the three experiments showed that the group members working anonymously generated more critical

comments than group members working identifiably. The findings of the current study contributed to the literature in this area.

Limitations

As with other studies of this type, the current study was exposed to threats to both external and internal validity in several ways. Every attempt to minimize the known threats was made by the researcher as well as the course instructor.

External Validity

A convenient sampling strategy from the experimentally accessible population in this study was not optimal. It is likely that the sample is not representative of its target population. The researcher had access to this potentially biased sample, as it is often the case in educational settings that random selection is not feasible. This study is further limited by its small sample size. Also detracting from external validity, this experiment is only a "one-shot case" in a particular setting, at a particular time, on a particular course, and with a group of particular subjects. It may not be able to capture the dynamics undergoing in the e-peer review environment. All these characteristics combine to lessen the confidence with which the researcher may make generalizations.

Internal Validity

Several factors might threaten the internal validity of this study. They are: selection, testing, instrumentation, and instructor effects.

Selection threat to the internal validity in this study involves group differences prior to the experiment. Limited by the fact that subjects could not be randomly assigned to the experimental and control groups, it is possible that there were some pre-experimental differences between the two groups. Therefore, causal relationship must be made with caution. To control for this threat, a writing pretest was administered, and student GPA information and SAT verbal scores were collected to check for group differences. No large group differences were found in either GPA (M = 3.06 for the anonymous group, M = 3.03 for the identifiable group) or SAT (M = 540 for the anonymous group, M = 561 for the identifiable group).

Because the current study involved the pre-test and post-test measures, there might be a testing threat to its validity. To minimize this threat, different essay topics were used for the pretest and posttest, and there was a 14-week internal between the pretest and posttest which was long enough to offset the testing effect.

This study may also be limited by the instrumentation threat. Assessing writing is a formidable task (Ransdell & Levy, 1996). There is no guarantee that a scorer would grade the 100th paper with exact the same criteria as he grades the first paper even though he uses the same instrument. In addition, the use of multiple scorers and different essay topics for pretest and posttest may as well contribute to the instrumentation threat. To reduce these threats, Ransdell-Levy's assessment procedure (described in the procedure section of Chapter 3) was employed to increase interrater reliabilities, and the two essay topics were deliberately selected by the instructor to match each other in style, tone, content, and requirements.

The questionnaire measuring student learning satisfaction was pilot tested with a group of students who were different from target population. Despite its high reliability, there might be validity concerns: some of the items in the questionnaire had to be excluded when conducting the pilot test, as they were not applicable to the pilot-testing sample. Aside from this, the measurement was based on the self-reported data. Even though students were assured that their responses would not affect their course grades, some students may still worry about the likely negative consequences caused by their responses to the questionnaire, as is true of all self-reported data. On the other hand, because there was no connection between the course grade and the questionnaire responses, some students may not take it seriously. This would cast doubt on the validity of the student responses.

There are some potential problems with the measurement of the critical peer feedback as well. The amount of critical peer feedback was measured by the number of negative comments that a reviewer gave on each draft. But the concepts of critical or negative feedback are hard to be operationally defined. A comment can be strongly negative, or mildly negative, or just a suggestion. No single instrument can satisfactorily measure all the related characteristics of criticism or negative feedback. What's more, a comment can be as long as a

paragraph, or as short as one word. Simply counting the number of comments obviously was not a perfect reflection of the amount of feedback. Of course, these concerns were beyond the investigation of this study, but it questions whether these measurements were accurate and inclusive. Another measure of the critical peer feedback—peer rating—may also be an issue. The peer suggested score only reflected the general impression of the reviewers on the overall quality of the drafts based on the evaluation rubric. There was no strict criteria as to what kind of paper should get a rating of 1, and what kind of paper should get a rating of 15. It was somewhat arbitrary and subjective. In addition, there was rater variation as well. The same paper may get different ratings when graded by different scorers. These limitations are very hard to control in writing assessment.

Another limitation impacting the validity of this study came from the instructor. Even though both the anonymous e-peer review group and the identifiable e-peer review group were taught by the same instructor, it did not guarantee that the pre-determined curriculum content and related information were presented exactly the same to the two groups. As we know, instructors often have to adapt their instructions from class to class according to different learning atmosphere, student feedback and some other factors no matter how hard they try to be consistent across classes. To minimize the effects caused by such phenomena, several variables were controlled: textbooks, assignments, exams, peer review process, course content, course requirements, class schedule, length of class time, class meetings per week were identical across the two classes.

Assignments of peer reviewers may also be an issue in this study. In the anonymous e-peer review group, authors' drafts were assigned to peer reviewers by the instructor on a random-rotating basis, which means that the students in this group had opportunities to receive feedback from as many as sixteen peers throughout the semester (eight required drafts, and each reviewed by two peers), whereas in the identifiable e-peer review group, all the authors' drafts were only reviewed by the other two members of the group. In such a case, the treatment effects might be confounded by the results of rotating peer reviewers. Namely, was it possible that the anonymous group outperformed the identifiable group because the students in this group

got ideas and perspectives from more peers than their counterparts in the identifiable group?

With all of these cautions in mind, the results of this study lead to number of recommendations in both practice and research. They detailed in the following sections.

Recommendations

Recommendations for Instructional Practices

The findings of this study have several implications for educators to consider when implementing peer review.

First, a carefully designed and more holistic approach to training in editing skills is crucial to the success of peer review. This study revealed that the top concern in carrying out peer review was students' suspicion against the quality of peer feedback as well as their own ability in giving feedback. This concern suggests that providing students with adequate training is not only necessary but also will lead to greater acceptance of peer review process and ultimately to enhanced student willingness to receive and give peer feedback. Training can provide students with the knowledge and the skills necessary to function comfortably as feedback providers and feedback recipients. The experimental study investigating the effects of training for peer response by Zhu (1995) provided strong empirical support to this argument. The results of this study illustrated that training students for peer response led to significantly more and better-quality peer feedback. Kerr et al. (1995) also realized the importance of training in peer review process. They corroborated that students clearly need some guidance and explicit training in assessing the work of others. According to the lessons gained from this study, a pre-treatment training alone is not sufficient. Students need ongoing guidance to address their specific needs. In addition to providing students with strictly enforced guidelines for editing as advocated by Guilford (2001), step-by-step hands-on practice should be delivered on the basis of students' need. As some of the students suggested, instructors may consider setting aside a couple of class sessions for hands-on practice some time after students are exposed to peer review process so that specific strength and weakness

of students' editing skills can be identified and the training can be more targeted. Additionally, Mangelsdorf's (1992) peer review training strategy "modeling the technique" may also help. Mangelsdorf spent class time modeling the peer review techniques to the students by first discussing the strengths and weaknesses of a couple of sample drafts and then practicing how to made suggestions for revision. Video modeling has also been found effective in training participants doing peer review (Topping, 1998).

The second implication is the demands for higher levels of accountability of the peer review process. Peer irresponsibility and procrastination was the second ranked top category that contributed to student dissatisfaction with peer review. Therefore, it is imperative to take additional strategies to necessitate incentives to entice students to be more serious with peer review. One possible strategy to strengthen student commitment to the peer review process is to grade student feedback as well as student papers by the instructor as was originally designed but not carried out to the letter in this study. Nilson (2003) also suggests that instructors can raise the quality of peer feedback by grading it. Zhao (1998) argued for a further step in this process. He insisted that accountability could be increased with reciprocity and a greater sense of responsibility and individual contribution: while reviewers were required to provide high quality feedback, authors should also be asked to take the reviews seriously. Another related strategy that might help to increase student responsibility in the peer review process is to make reviewers' ratings affect the grades of reviewees. In this way, peer reviewers would feel obligated to give their peers more fair and reasonable ratings and feedback, which would push them to put forth more efforts on peer review. This strategy was also recommended by Kerr et al. (1995) after they evaluated a 2-year program involving peer grading of essays, but they preferred to restrict peer grading to a relatively small portion of the student's total grade.

The third consideration in implementing peer review was the group management. Problems with group dynamics were another important factor that accounted for student negative attitudes toward peer review. Problems such as lack of cooperation, member conflict, uneven feedback quality, inappropriate reactions to feedback, etc. were repeatedly mentioned by the students in the identifiable group.

Effective measures relating to group size, group formation, group composition, and so on need to be taken to solve or reconcile these problems and conflicts so as to elicit behavior conducive to effective group performance for peer review. After reviewing his students' complains about peer review, Mangelsdorf (1992) exclaimed that peer review session had to be carefully organized in order to be successful. McIsaac and Sepe (1996) agreed that successful peer review groups require a lot of organization from the instructor.

Lastly, even though two students in the anonymous group stated that they would rather know who reviewed their papers, there were more students in the identifiable group who expressed their strong preferences to anonymous peer review and argued that some peer review problems could be solved by reviewing each other's papers anonymously. If it is immature to declare that anonymous e-peer review is superior to identifiable member peer review just based on this small-scale experiment, at least it provided a good alternative method in peer review approaches, which may help educators make rational choices between alternative practices and build a stable foundation of effective practices.

Recommendations for Future Research

This study added to the research on peer review and peer evaluation by investigating the effects of anonymous e-peer review versus identifiable e-peer review on student writing performance, learning satisfaction and critical feedback. The insights gathered from this study, although helpful, are in no way exhaustive. There exists a great potential for further research in this area.

First of all, further research needs to address the limitations of the current study. Because the sample size of this study was small and the sample selection was not on a random basis, design changes that would most logically improve the study would include expanding sample size and utilizing randomization, which would help eliminate the threats to external and internal validity and make the findings more generalizable to similar situations. As well, the design of this study was basically quantitative, geared to provide quantitative evidence for the effectiveness of anonymous e-peer review. Only minimal qualitative

data were collected and analyzed. To gain a better and more profound understanding of how and why anonymous e-peer review was more effective, a more comprehensive qualitative study including interviews and/or analysis of feedback should be employed.

Considering the limitations of the questionnaire (the pilot-testing population was different from the target population), a more psychometric work on the instrument measuring student satisfaction with peer review and peer feedback might be needed to further validate the reported findings of this study.

This study has suggested that introducing anonymity in e-peer review would produce more gains in student writing performance and greater amount of critical peer feedback, but have no significant effects on student learning satisfaction. Given these findings, another area that warrants further investigation could be whether there is relationship between the amount of critical feedback and student writing performance and whether there is relationship between the amount of critical feedback and student learning satisfaction.

This study was confined to a freshman writing course, and therefore the results may not be generalizable to students taking other courses or in different grade levels. Does anonymous e-peer review work equally well for other academic majors? Is anonymous e-peer review more beneficial to sophomores, juniors, seniors or graduate students? These are promising variables to investigate in further research.

Given the significant findings concerning achievement gains in writing performance made by the students in the anonymous e-peer review group, future research may consider including mid-term measures in addition to pre- and post-measures to investigate the pattern of achievement improvement. Specifically, by comparing pretest results with mid-term results, and mid-term results with posttest results, it would illuminate trends in the treatment impact—do students make steady progress throughout a semester? Or do students make greater progress between pretest and mid-term test? Or do students make greater progress between mid-term test and posttest? These findings would provide valuable information to assist educators in deciding the duration of the treatment in order to maximize the benefits of this instructional strategy.

The impact of anonymous e-peer review on male students versus female students also warrants further study. Despite the fact that the overall student demographics matched closely between the two groups, there were more male students in the anonymous group than in the identifiable group ($N = 6$ vs. $N = 2$). According to the studies on field-independent / field-dependent learning styles, males tend to be more field-independent than females, which means that males usually perform better when working independently than working with others (Hansen-Strain, 1993; Kalgo, 2001). It might be interesting to redesign this study using gender as an independent variable to determine whether anonymous e-peer review leads to better writing performance for males compared to females.

Another direction that could be explored by future research may be the relationship between the number of assignments for peer review and student academic and attitudinal outcomes. For this study, there were nine assignments throughout the semester, eight of which required peer review. According to the anecdotal impression of the teaching assistant and the researcher, some students felt somewhat overwhelmed by the task of writing drafts, filing peer feedback and revising papers. Based on the literature reviewed, none of the previous studies required as many assignments for peer review within a semester. Would fewer assignments reduce the demanding workload so that students can devote more time and effort in reviewing peers' papers and consequently it helps guarantee quality feedback and thus increase student satisfaction with the peer review process?

Although this study examined the effects of anonymous e-peer review on student academic and attitudinal outcomes for one semester, a longitudinal study is recommended to determine if the students in the anonymous e-peer review group continue to show greater improvement in their writing performance over time after they were removed from the treatment.

In this study, critical feedback was simply operationalized as the number of negative comments. Additional research is needed for a more complete understanding of different types of critical feedback and their impacts on student learning and perception. How could different types of negative feedback be defined and/or categorized? Would strong criticism lead to greater academic achievements and/or

more positive attitudes? Or would mild criticism or suggestions work better? What types of critical feedback are students more willing to incorporate in their revision?

One more direction that could be explored is the different types of peer feedback provided by the anonymous group versus the identifiable group. In addition to more critical peer feedback given by the anonymous group, the data from this study also revealed that there were more peer comments regarding the organization and contents (e.g. focus, interestingness, examples) of the reviewed drafts from the anonymous group. In comparison, the peer comments from the identifiable group largely centered on grammar, spelling, and diction. This is another indicator that peer reviewers in identifiable condition were more concerned about peer reviewees' reaction to their feedback. As an expedient measure, they tried to avoid mentioning the areas that might cause conflict, only touching upon those issues that were easily accepted by the reviewees. Therefore, future research needs to address whether differences in the types of peer feedback are statistically correlated to different delivery modes of peer feedback and whether different types of peer feedback have different impacts on student learning and perception.

The final area that warrants further investigation is to replicate this study by taking the time class sessions into consideration. Anecdotally from the experiences of the instructor, it is felt that the morning session class (11:00 am – 12:15 pm) often performs and behaves better than the afternoon session class (1:30 pm – 2:45 pm). Was there any possibility that the anonymous e-peer review group outperformed the identifiable e-peer review group because it happened to be a morning session class? To eliminate any doubts, the instructor and the researcher replicated this study in the following year by purposefully assigning the afternoon session class to the anonymous group. The results of this replication study will strengthen the external validity of the present findings.

CONCLUSIONS

This study was undertaken to add to the limited body of knowledge on anonymous e-peer review and evaluation in college writing instruction. Although there are limitations, the researcher believes that it holds promise for four reasons.

First, this study used a quasi-experimental design to compare the effects of anonymous e-peer review with identifiable e-peer review. The findings obtained from both quantitative and qualitative data, though far from flawlessness, are informative. Second, this study expanded the research literature on anonymous peer review. Previous studies mainly focused on the critical nature of peer feedback and the psychological consequences caused by anonymity. This study took a further step in this area by examining the impact of anonymous e-peer review on student academic achievement and learning satisfaction. Third, this study laid a foundation for the feasibility and importance of online writing instruction. Currently, writing instruction is largely confined to face-to-face education. However, as the world becomes more and more connected through electronic communication and people become more and more dependent on Web resources, exploring an effective writing instructional strategy in online collaborative environments becomes imperative. It is an area ripe for investigation, and deserves attention. The current research took a small step toward this direction. Last, although the current study failed to produce conclusive results on student perceptions, the ultimate indicator of course effectiveness is the degree to which students reach the learning objectives. To this end, using anonymous e-peer review in writing instruction is a worthwhile endeavor.

APPENDIX A

SIX-SUBGROUP QUALITY SCALE (SSQS)

Subgroup 1—Words: Choice and Arrangement

1. Readable vs. Awkward

This is a measure of how well the reader can derive meaning from the sentence. Essays should be read aloud for this point only. (NOTE: pausing to derive meaning from the sentence should only be considered when it is attributable to the essay and not the rater.)

> 5 = When reading aloud, all sentence meanings are crystal clear the first time. It is not necessary to pause and think.
>
> 4 = When reading aloud, all sentence meanings are clear the first time. Some pausing to think is needed.
>
> 2 = When reading aloud, more than one sentence needs to be repeated to derive meaning. The writer's intent / idea is ambiguous.
>
> 1 = After repeating, writer's intent is still unknown.

Subgroup 2—Technical Quality: Mechanics

The three technical ratings (tenses, grammar and spelling) will be more quantitative than qualitative in nature than the remaining. In rating these points, a predetermined number of errors should define "many" and "few" based on the average length of the essay.

2. Tenses

> 5 = All tenses correctly used.
> 4 = Most tenses correctly used.
> 2 = Most tenses incorrectly used.
> 1 = Consistent tense errors throughout.

3. Grammar

> 5 = Almost no grammatical errors.
> 4 = Few grammatical errors.
> 2 = Many grammatical errors.
> 1 = Little evidence of grammatical knowledge. Very poor grammar throughout.

4. Spelling

Incorrect hyphenation within words or making one word into two (i.e., "class room," rather than "classroom") is considered spelling errors, not grammatical errors. Obvious typos are not to be considered misspelled words. Additionally, incorrectly spelled words can be attributed to typing errors if they are correctly spelled in another part of the essay.

> 5 = No misspelled words.
> 4 = One misspelled word.
> 2 = Two or more misspelled words.
> 1 = Two or more misspelled words with some of them being commonly used words (elementary school level).

Subgroup 3—Content of Essay

The next two scales are an evaluation of the writer's global attitude with regard to the assigned topic.

5. Engaged vs. Uninvolved

> 5 = Extremely serious or passionate and very engaged with the subject at hand; formal and not redundant. No use of inappropriate jokes.
> 4 = Not quite as engaged or passionate as a 5 rating, while remaining formal and not redundant; serious and almost no use of inappropriate jokes.
> 2 = Some inappropriate use of jokes and not very serious; casual and unengaged.

1 = Many inappropriate use of jokes and a sense of not really caring about the topic. Very redundant, casual and uninvolved.

6. Alternative Points vs. Egocentric

Does the writer ever acknowledge the existence of anyone other than him or herself? When a writer refers to his or her argument as "my opinion", he or she thereby acknowledges that other points of view exist, even though other viewpoints may never actually be discussed in the essay.

> 5 = Consistent acknowledgment and discussion of other points of view.
> 4 = Some acknowledgment and discussion of other points of view.
> 2 = Few acknowledgment and almost no discussion of other points of view. Very vehement and closed-minded.
> 1 = Almost no acknowledgments and a lack of discussion of other points of view. Very vehement and closed-minded.

Subgroup 4—Purpose/Audience/Tone

7. Purpose Clear vs. Unclear

A clear and definite statement of purpose with elaboration would be rated high. A stated purpose for writing is usually evident by the end of the first paragraph.

> 5 = There is definite statement of purpose, and at least 75% of body revolves around the thesis.
> 4 = When 50 to 75% of body revolves around the statement of purpose.
> 2 = There is no statement of purpose, but essay has coherence.
> 1 = There is no statement of purpose, and essay is sporadic.

8. Language and Tone Appropriate/Consistency

Depending on the topic, raters must decide if they are seeking appropriate language and/or looking for consistency throughout the essay with regard to language and tone. Examples of informal words include "a lot" and "kind of". Clichés and second person are also in inappropriate.

> 5 = Respectful, formal and no sarcasm. Nearly total consistency.
> 4 = Respectful and formal containing almost no sarcasm or double meanings. Almost no inconsistencies.
> 2 = Containing some sarcasm or jokes; casual; 50% of essay does not use the same language and / or tone as the other 50%.
> 1 = Very casual bordering on disrespectful, sarcastic and / or containing jokes. Essay is totally disconnected throughout.

Subgroup 5—Organization and Development

9. Support and Elaboration

This point quantitatively measures the number of arguments and how well they are presented.
First, establish how many arguments constitute "few" and "many". The degree of elaboration will differentiate between a rating of 4 and 1 and a rating of 5 and 2. Marking each reason as you read the essay is helpful.

> 5 = Many different reasons and at least 65% are elaborated.
> 4 = Few reasons and at least 65% are elaborated.
> 2 = Many reason and less than 65% are elaborated.
> 1 = Few reasons and less than 65% are elaborated.

10. Sense of Completeness

> 5 = All thoughts or ideas tied together by one or more conclusions.
> 4 = Most thoughts or ideas tied into a conclusion.

2 = No general conclusion, but thoughts have closure.
1 = No conclusions.

11. Paragraphing

5 = Sufficient use of paragraphs between though. Paragraphs contain an opening sentence and some elaboration. They should end with a sentence that leads smoothly into the next paragraph.
4 = Sufficient use of paragraphs between though. Paragraphs contain an opening sentence nd some elaboration. Choppy transitions between paragraphs.
2 = Insufficient use of paragraph. Only 1 or 2 paragraphs used when 5 or 6 are needed or excessive use of paragraphing. Almost no use of opening sentences. Choppy transitions.
1 = No paragraphing is used or paragraphing is arbitrary.

Subgroup 6—Style

Scale 12 and 13 should be assessed assuming the writer possesses a collage level use of English.

12. Sentence Structure and Conciseness

5 = Almost no run-on sentences or wasted words. Clear and to the point.
4 = Almost no run-on sentences, few wasted words.
2 = Redundant and immature. Not clear or concise.
1 = Many wasted words and many run-on sentences. Immature.

13. Daring versus Safe

Be careful not to let opinion enter here.

5 = Unique ideas and very mature, creative, extensive use of the English language.

4 = Unique ideas or very mature, creative extensive use of the English language.

2 = No new thoughts and moderate use of English.

1 = No new thoughts and / or very simple English with a limited vocabulary.

APPENDIX B

STUDENT LEARNING SATISFACTION QUESTIONNAIRE

The purpose of this questionnaire survey is to give you a chance to tell us how you feel about your learning experiences in this course, what things you are satisfied with and what things you are not satisfied with. As we have asked you to give feedback to one another during this course, we would like you to give feedback to us so that we may know the effectiveness of this course.

Please note that your evaluation is important for making improvements to this course for future students, and it is essential for the present research on the strategies of teaching writing. On the basis of your answers, we hope to get a better understanding of the things individuals like and dislike about this course. Please read each statement in the following page carefully and take the time to **carefully complete EACH question**. Your responsible, thoughtful and constructive feedback will be much appreciated. **Please be assured that all responses will be kept in strict confidence**. Your name is required simply to enable matching of data across assessment. In no case will an individual's identity be revealed in any report or publication. **The results of the evaluation** will be carefully reviewed by the researcher and **will be reported to the instructor only after the final grades have been submitted.**

Thank you for your assistance.

(Please continue on the next page.)

STUDENT LEARNING SATISFACTION QUESTIONNAIRE

Course Title: **Instructor:** **Semester:**

Class session: ☐ **11:00** ☐ **1: 30** **Date:** ___/___/_____

Demographic Information

Name: _____ UID#: _____

Gender: ☐ Male ☐ Female Age: ____ Race/Ethnicity _____

Class Standing: ☐ Freshmen ☐ Sophomore ☐ Junior ☐ Senior

GPA: ____(College) GPA: ____(High School) SAT (Verbal): ___

Ever Attended any Writing Programs: ☐ Yes ☐ No

You are a: ☐ Full Time Student ☐ Part-time Student

Major: _____ Expected Grade for This Course: _____

You took this course because

 ☐ It was a required course toward a degree program.

 ☐ It was an elected course toward a degree program.

 ☐ I had a general interest in the subject.

 ☐ This instructor taught the course.

Read each statement below and then **circle the number** that best represents the extent to which you agree with each statement. Please answer **ALL** questions and give **ONE** answer for each question.

Ranking Code

 SD = Strongly Disagree **D = Disagree**
 A = Agree **SA = Strongly Agree**

I. Perceived Satisfaction with the Course	SD	D	A	SA
1. I enjoy the course.	1	2	3	4
2. I am satisfied with the overall quality of the course.	1	2	3	4
3. I am satisfied with the degree of academic challenge of the course.	1	2	3	4
4. The learning environment of the course is very good.	1	2	3	4

	SD	D	A	SA
5. My objectives of taking his course were achieved.	1	2	3	4
6. The assignments tied in with the course objectives.	1	2	3	4
7. The requirements of the course are reasonable and useful.	1	2	3	4
8. I've learned how to be a more effective writer in this course.	1	2	3	4
9. The knowledge and skills acquired in this course prepared me for my profession.	1	2	3	4
10. This course is valuable to my overall education.	1	2	3	4

II. Perceived Satisfaction with the Assessment System

	SD	D	A	SA
11. The assessment system motivated me to do my best work.	1	2	3	4
12. The assessment system is appropriate for this subject.	1	2	3	4
13. The assessment system created a learning environment in which I felt comfortable.	1	2	3	4
14. *The assessment system was too demanding.	1	2	3	4
15. The assessment system made me feel responsible for my own learning as well as for others' learning.	1	2	3	4
16. The assessment procedure is well organized.	1	2	3	4
17. I turned in papers and required work on time.	1	2	3	4
18. My peers turned in papers and required work on time.	1	2	3	4
19. The use of web-based learning tool "*Blackboard*" for this course is fun and efficient.	1	2	3	4
20. *Too much of learning time was taken up doing assessment tasks.	1	2	3	4
21. As a result of the assessment process, I feel very confident in my ability to analyze, criticize and evaluate others' work.	1	2	3	4
22. As a result of the assessment process, I feel very confident in my ability to analyze, criticize and evaluate my own work.	1	2	3	4

III. Perceived Satisfaction with Peer Feedback

	SD	D	A	SA
23. I enjoy giving and receiving peer feedback.	1	2	3	4
24. I believe that it is very important for me to learn how to give and take feedback.	1	2	3	4
25. Giving and taking feedback is an effective approach in sharpening my critical and analytical skills.	1	2	3	4
26. I'm satisfied with the overall quality and usefulness of feedback.	1	2	3	4
27. My peers gave adequate feedback on my written work.	1	2	3	4
28. The peer feedback I received generally helped a lot.	1	2	3	4
29. I think I have learned more from peers' feedback than from the instructor's feedback.	1	2	3	4
30. The grades my peers gave reflected the overall quality of my work.	1	2	3	4
31. *Giving feedback to peers is frustrating.	1	2	3	4
32. *There was a lot of pressure on me to give feedback to my peers.	1	2	3	4
33. I wish I could have known who reviewed my paper rather than doing it anonymously.	1	2	3	4

IV. Open-ended Questions

34. How do you evaluate your peers' ability in giving feedback?

35. How do you evaluate your own ability in giving feedback?

36. What were the advantages of the peer review?

37. What were the disadvantages of the peer review?

38. How could the peer review process be improved?

Note: *Anonymity Manipulation Checks*

39. Were you able to identify specific comments to a specific editor?

 ☐ Yes ☐ Most Likely ☐ Most Unlikely ☐ No

40. Were other members of your class able to identify specific comments to a specific editor?

 ☐ Yes ☐ Most Likely ☐ Most Unlikely ☐ No

(This is the end of the questionnaire. Thank you.)

APPENDIX C

EDITOR WORKSHEET

- Assignment #: _____
- Title of the Paper: _____
- Editor Class ID: _____ Author Class ID: _____
- Paper Overall Score: 1 2 3 4 5 6 7 8
 9 10 11 12 13 14 15

Rating Each Element as to its Success

		High			Low
F	Focus	4	3	2	1
O	Organization	4	3	2	1
C	Content	4	3	2	1
U	Usage (grammar/spelling/usage)	4	3	2	1
S	Style	4	3	2	1
E	Examples	4	3	2	1
D	Diction	4	3	2	1
I	Interest	4	3	2	1
T	Tightness	4	3	2	1

FOCUS EDIT COMMENTS:

OBSERVATIONAL COMMENTS:

APPENDIX D

AN EXAMPLE OF AN EDITED DRAFT

Author Class ID: 9362
Assignment #1 Fern

Advantages/Disadvantages of Career of Your Choice

All career choices have many advantages and disadvantages to them. My career choice is Mechanical Engineering. In my case, my career choice's advantages outweigh its disadvantages; because of this I believe that it is the right career for me. This is the kind of career that I believe I will enjoy and that will financially take good care of me.

Some of the advantages to Mechanical Engineering are it has a good starting pay, room to grow in the field of work, and it is also the type of job that I would enjoy. Mechanical engineering is basically the researching and testing of all kinds of products, and improving or redesigning them, which I love to do. This career has one of the widest ranges of job opportunities which are steadily increasing. With the advances in computer technology there are many new programs to help quickly draw and test different designs before manufacturing the product.

One of the disadvantages to my career choice is the difficulty and the coarse load of the degree. Also the career may get stressful at times with the extensive research and deadlines on improvements and finishing projects. The only drawbacks to the advances in computer technology is that the software will take place of many Mechanical Engineers in the fields of research and development; however, there will still be a demand for manufacturers.

Mechanical Engineering seems to be a good career for me because all of the advantages of this job, for me, out weigh the disadvantages. The biggest advantage is that I will enjoy it because it interests me and it's not just a job I will go to every morning and come home to complain. The advantages and disadvantages of my career choice cancel each other out but there are more advantages than disadvantages.

You have chosen a good career to write about, but you should give the paper a title such as "Mechanical Engineering".

You have a good introductory paragraph. Maybe include more of what you are going to talk about in the rest of the body.

You gave a good description of Mechanical Engineering.
You should state the title of your desired occupation instead of repeating "my career choice".

Your paper is formatted well, and the paragraphs flow nicely together. The introductory sentence of the third paragraph may sound better if it said, "One disadvantage of Mechanical Engineering is the difficulty of the course load for the degrees and experience required to be a prime prospect of employers."

APPENDIX E

AUTHOR RESPONSE SHEET

- Assignment #: _____
- Title of the Paper: _____
- Author Class ID: _____ Editor Class ID: _____
- Paper Overall Score: 1 2 3 4 5 6 7 8
 9 10 11 12 13 14 15

1. Please grade the overall usefulness of the comments of the editor?
 1 2 3 4 5
2. What specific comments and suggestions of the editor did you use in revising your draft?

3. What specific comments and suggestions of the editor did you disagree with?

4. Are there any comments or areas not mentioned by the editor but you would find helpful for improving your paper?

5. What points of suggestions or encouragement would you like to offer to the editor?

APPENDIX F

ENGLISH COMPOSITION COURSE SYLLABUS

Course Sections: TR *11:00 am – 12:15 pm* *Room: ED 150*

Instructor: Dr. XXX, Eminent Professor of Education Reform
Office: ED 153A / Office phone: (XXX) XXX-5151
Home Address: (*omitted here*)
Home Phone: (XXX) XXX-9173 / Email: (*omitted here*)

Assistants: XXX, Teaching Assistant
Office: ED151 / Office phone: (XXX) XXX-6459
Email: (*omitted here*)

XXX, Computer Assistant
Office: ED 251 / Office phone: (XXX) XXX-6459
Email: (*omitted here*)

XXX, Research Assistant
Office: ED 251-7/Office phone: (XXX) XXX-6042
Email: (*omitted here*)

Required Texts: Anno's Journey, Mitsumaso Anno
Quick Access, 3rd Edition, Simon & Schuster
Course Website: (*omitted here*)

Your instructor will read **all papers, reviewer's feedback, author's response to the editing**, and do the bookkeeping of all assignments. You will also have the opportunity to have conferences with the instructor and your teaching assistant to discuss editing suggestions. The instructor is always available. Feel free to call him in his office or at his home to make an appointment for any reason. In addition, you will have computer support. The computer lab will be dedicated to your computer support during activity hours over the lunch period on Tuesday and Thursdays.

Our course computer assistant will try to be available at other times on request.

Course Objectives:

1. To write better
2. To write faster
3. To edit better and recognize the difference between good and bad writing
4. To enjoy the writing process more
5. To develop career selection skills

Multiple Drafts:

Papers will be submitted in two drafts:
Fern (1st Draft)
Coal (2nd Draft—graded)
Diamond (3rd Draft) – optional

Typing and Format Requirements:

Student Course ID and Class session must be typed at top right of page 1.
Assignment Number and Draft Name must be typed on second line.
All drafts of papers written outside of class must be in digital format.
All papers must be double-spaced.
All papers must be sent in **word document** as an **attachment**. Save the document using your **Course ID Number + Assignment Number + Paper Name (e.g. 1234_#1 Fern; 0012_#5 EF; 3456_#7 AF; 2345_#9 Coal).**

Attendance:

Attendance is required. Students will select seats and a seating chart will be prepared. Students should sit in the same seat for each class. Attendance checks will be made. More than two unexcused

absences can result in the reduction of your course grade, up to one full grade. **If a student misses more than SEVEN classes, they automatically fail the course.**

Accommodation for students with disabilities:

If there is a student in this class who has special needs because of a disability, please feel free to notify the instructor to discuss the accommodation process.

Grading Policy:

All drafts of all assignments, editor's feedback and author's responses will be posted in

<u>Blackboard</u>

Peer grading will be used for all the drafts (Fern) of writing assignments, except one In-Class Writing (it is graded only by the instructor).

Random anonymous peer review is the approach that the course takes to provide peer feedback. Each student will be given a **Course ID Number** that the student must use in all papers and feedback sheets **instead of his or her name**. Students should remember their own Course ID Number and must **NOT SHARE** it with other students (sharing your Course ID is a violation of our Course Honor Code, and you are jeopardizing your course grade by doing this).

Fern (first draft) will be anonymously graded by two randomly assigned peers in the editing process, but will not be graded by the instructor.

The instructor will grade coal (second draft), as well as Editor Worksheet and Author Response Sheet.

The instructor will decide the grade of an assignment on the basis of **three factors**: the quality of the paper (Coal), the quality of the feedback provided on the drafts reviewed (based on the edited

drafts and the Editor Worksheet), and the quality of feedback provided to the editors (based on the Author Response Sheet). Students are encouraged to write a third draft (Diamond) to take advantage of the instructor's feedback. If at the end of the semester your grade is on the borderline, the number and quality of the Diamond drafts will determine the final grade.

Any piece of late work (posted on *Blackboard* after the due date, including late papers, late Editor Worksheets and late Author's Responses) **will lead to 40 points deduction** from the 100 total points for each assignment which cannot be made up.

Course Schedule

Date	Class Activities & Introduction of Assignments
Aug 26	Introduction of Syllabus Student Information Sheets Completed Sign up for Individual Meetings
Aug 28	In-Class Writing Sample (Pretest)
Sep 2	Discussion: The Peer Editing Process: FOCUS EDIT; Topic Selection and Nuggets or Bullets
Sep 4	Discussion: Author Response to Editing Paragraph Organization & Outline
Sep 9	Blackboard Orientation
Sep 11	Reorganization & Final Edit Discussion: Descriptive Prose I Assignment #1: "Advantages and Disadvantages of a Career of Your Choice" **(300 W, due on the following Monday)**

Sep 16	Discussion: Juxtaposition
	Discussion: Effective Human Relationships
	Assignment #2: "Developing Effective
	Human Relationships"
	(300 W, due on the following Monday)

Sep 18 — Visits by Writing Tutorial Services and the Honor Council

Sep 23 — Discussion: The Criterion of Focus
Discussion: Estimation as a technique for studying the future

Sep 25 — Discussion: Persuasion I
Assignment #3: "Persuading a Friend of the Importance to Study the Future"
(500 W, due on the following Monday)

Sep 30 — Discussion: The Criteria of Creativity & Unexpected Elements
Descriptive Prose II

Oct 2 — Discussion: Metaphors and Analogies to study the future
Assignment #4: "Three Ways to Study the Future"
(500 W, due on the following Monday)

Oct 7 — Discussion: Logical Development Discussion: Case Studies

Oct 9 — Discussion: The Criteria of Interest
Discussion: Introduction to Anno's Journey

Oct 14 — *Fall Holiday*

Oct 16 — Discussion: Introduction to Anno's Journey
Assignment #5: "Motif's or Subplots from Anno's Journey"
(500 W, due on the following Monday)

Oct 21	The Criteria of Example Discussion: Peer Pressure
Oct 23	The Criteria of Tightness
Oct 28	**Persuasion II: In-Class Writing (Assignment #6)**
Oct 30	The Criteria of Diction & Wordiness Assignment #7: "Anno #2" **(500 W, due on the following Monday)**
Nov 4	The Criteria of Syntax & Usage Discussion: Anno's Journey
Oct 23	Discussion: Study Skills Sign up for Individual Meetings Assignment #8: "Perspective: Pick a Contemporary Issue and Give Arguments on Both Sides" **(500 W, due on the following Monday)**
Nov 11	**Individual Meetings**
Nov 13	Discussion: Resumes Assignment #9: "Resume" **(300 W, due on the following Monday)**
Nov 18	Discussion: Uncertainty – Trial and Error to study the future Discussion: Careers Choice
Nov 20	Discussion: Communication Skills Discussion: The Criteria of Style
Nov 25	Discussion: Paradox
Nov 27	**Happy Thanksgiving!!**

Dec 2 **In- Class Writing Sample (Posttest)**

Dec 4 **Questionnaire Survey & Class Retrospectives**

Dec 9 **Final Examination – 12:30-3:30 pm**

**

Summary of Assignments

Words	Ass#	Title
300	1	Descriptive Prose 1: Advantages/Disadvantages of Career of Your Choice
300	2	Descriptive Prose 2: Developing Effective Human Relationships
500	3	Persuasion 1: Persuading a Friend of the Importance to Study the Future
500	4	Descriptive Prose 3: Three Ways to Study the Future
500	5	Motifs or Subplots from <u>Anno's Journey</u>
500	6	Persuasion 2 (In Class)
300	7	Anno #2
500	8	Perspective: Pick a contemporary issue and give arguments on both sides
300	9	Resume
600	10	Final Exam Essay (draft and rewrite)

**

Date		Assignment Due
August 28	T	***In-Class Writing (Pretest)***
Sep 15	M	Assignment #1: Fern Due
Sep 17	W	Editor Feedback Due
Sep 19	F	Coal + Author Response due
Sep 22	M	Assignment #2: Fern Due
Sep 24	W	Editor Feedback Due
Sep 26	F	Coal + Author Response due

Sep 29	M	Assignment #3: Fern Due
Oct 1	W	Editor Feedback Due
Oct 3	F	Coal + Author Response due
Oct 6	M	Assignment #4: Fern Due
Oct 8	W	Editor Feedback Due
Oct 10	F	Coal + Author Response due
Oct 13 - 17		***Happy Holidays***
Oct 20	M	Assignment #5: Fern Due
Oct 22	W	Editor Feedback Due
Oct 24	F	Coal + Author Response due
Oct 28	T	***Assignment #6: In-Class Writing (Mid-Term)***
Nov 3	T	Assignment #7: Fern Due
Nov 5	W	Editor Feedback Due
Nov 7	F	Coal + Author Response due
Nov 10	M	Assignment #8: Fern Due
Nov 12	W	Editor Feedback Due
Nov 14	F	Coal + Author Response Due
Nov 17	M	Assignment #9: Fern Due
Nov 19	W	Editor Feedback Due
Nov 21	F	Coal + Author Response due
Nov 24 - 28		***HAPPY THANKSGIVING!!***
Dec 2	T	**In-Class Writing—Posttest**
Dec 4	R	**Questionnaire Survey**
Dec 9/11		**Final Exam**

Cumulative Themes for Writing Focus

Fern Strategies

1. **Nuggets or Bullets** - thinking through the topics to be included as a casual, background activity before sitting down to write. Topics are not put in any order of priority, presentation, or importance. It is desirable to produce more "bullet" ideas than can possibly be used.

2. **Topic Selection** - the importance of selecting a topic which helps organize your writing, which is familiar, focused, and

experience and resource rich enough to support the writing objective in length, scope, and interest.

3. **Paragraph Writing, Rough Outline, Formal Outline**
4. **Paragraph Organization** - developing a topic sentence that, in most, but not all instances, is the first sentence of a paragraph and ensuring that all sentences relate to that single topic.
5. **Logical Development** - identifying major claims to be made with the responsibility of developing support and backing for the claims, pointing out possible refutations and rebuttals, and adding the qualifiers that will lend credibility to the claims.

In some instances the topic sentence will be written after the paragraph ideas have developed in ways not earlier anticipated, to allow writers the flexibility of revision in their paragraph and topical development.

Peer Editing

The opportunity to respond to the written work of others helps develop perceptual skills of distinguishing between good and poor writing. These skills can eventually be applied to the critique of one's own writing.

Author Response

The opportunity to respond to the comments of others helps develop critical thinking skills of assessing the usefulness of the critique of others, and thus provides the opportunity to reflect one's own writing more deeply and critically.

Coal Strategies

Final revision to include consideration of editing suggestions from peers, careful review for syntax, spelling, and punctuation errors by peers

Diamond Strategies

Opportunity to consolidate writing skills and to incorporate TA's feedback in the refinement of the paper

**

Drafting, Editing and Revision Schedule

1. Assignments will be introduced by the instructor on the date shown on syllabus.
2. Fern must be submitted on *Blackboard* for peer review every **Monday before 7:00 p.m.** (see exceptions on syllabus).
3. Editor Worksheet and edited drafts must be submitted on *Blackboard* every **Wednesday before 7:00 p.m.** (see exceptions on syllabus).
4. Coal and Author Response Sheet must be submitted on *Blackboard* for the instructor review every **Friday before 7:00 p.m.** (see exceptions on syllabus).
5. The instructor feedback and grading will be available on *Blackboard* by the next **Tuesday**.

**

FOCUS EDIT: a Key for Editing

In this class great emphasis is placed on the editing process. Most writers find that it is much quicker to write early drafts without worrying about fine editing, or even basic elements such as logic, repetition, organization, and the use of examples. In this class all students will be required to produce multiple drafts of each paper

It is recommended that rough drafts be prepared very quickly, getting ideas on paper, without worrying about what a final draft will look like. Some students have found that it is useful to prepare several rough drafts before giving them to group members for peer editing.

There are many approaches to editing. In this class, because most students have done little if any editing before, we will use a very structured process called FOCUS EDIT. FOCUS EDIT is an acronym to remind an editor of points to watch for while editing.

F	Focus
O	Organization
C	Content
U	Usage (grammar/spelling/usage)
S	Style
E	Examples
D	Diction
I	Interest
T	Tightness

We will study each FOCUS EDIT element in detail as the semester progresses. However, you will begin to use them to guide your editing immediately. As you comment on your peer's keep FOCUS EDIT elements in mind.

Two types of editing will be used on the draft:

1. **Embedding editing**: Specific comments on the draft and suggestions about how to improve the draft should be **embedded** in the draft (word processing > tools > track changes > highlight changes > track changes while editing). Technical help is available if need.

2. **Filing Editor Worksheet:** After you have completed editing the paper, you will prepare an Editor Worksheet for each draft you reviewed (FOCUS EDIT sheet), rating each element as to its success: **4** indicates an outstanding job, **3** is positive, **2** is negative, **1** means that the paper has serious difficulty on this dimension.

For each draft you edit, you must **select two, and not more than three** FOCUS EDIT elements to emphasize for compliments and the same for which you will give specific suggestions for improvement. Write them down on the Editor Worksheet. If you have any other comments and suggestions, write them down on the Editor Worksheet as "Observational Comments".

Both the edited drafts and the Editor Worksheet should be posted as a reply to the draft on *Blackboard* every **Wednesday before 7:00 p.m**.

Editor Worksheet is attached to the course syllabus and also available on *Blackboard* in "Course Documents".

Author's Response to Editor

Feedback is essential in learning not only for authors but also for editors. Authors need feedback to improve their writing skills, and editors need feedback to improve their editing skills. In order to receive meaningful and helpful feedback from peer editors, it is important for authors to "provide feedback on feedback". So after receiving the edited draft and the Editor Worksheet, authors are required to assess the quality of the editor's feedback, file an Author Response Sheet for each of the two editor and post them on *Blackboard* on the due date (**every Friday before 7:00 p.m.** with three exceptions).

Author Response Sheet is attached to the course syllabus and also available on *Blackboard* in "Course Documents".

Editing Procedure

1. Student authors anonymously post their drafts (Fern) on *Blackboard* for peer review on the due date (every **Monday** before **7:00 p.m.** with three exceptions), which both the instructor and the whole class have an access to.

2. For each assignment, each student must anonymously review two drafts randomly assigned to him / her by the instructor based on the FOCUS EDIT rubric. Both the edited draft and the Editor Worksheet for each author must be anonymously posted on *Blackboard* by the due date (every **Wednesday before 7:00 p.m.** with three exceptions), which both the instructor and the whole class have an access to.

3. Student authors revise their draft based on their peer editors' feedback and their own reflections on their drafts (students are required to consider their peers' feedback seriously, but feel free to take or ignore any comments in their revising process). Both the

revised papers (Coal) and Author Response Sheet for each editor must be posted on *Blackboard* for the instructor review by the due date (every **Friday before 7:00 p.m**. with three exceptions), which both the instructor and the whole class have an access to.

4. The instructor reviews **the revised paper (Coal) as well as the Editor Worksheet and the Author Response Sheet, on the basis of which the assignment grade is given**. The instructor feedback on the Coal and the grade for each assignment is available on *Blackboard* every Tuesday with three exceptions).

The End

APPENDIX G
COURSE GRADING SHEET

(*Course Title & Number*) **Class Session** ☐ **11:15** ☐ **1:30**

Assignment # : **Title** _____

STUDENT CLASS ID	DRAFT (FERM)				COAL		FINAL GRADE
	EF1 15	EF2 15	AR1 15	AR2 15	P 40	D - 40	100

EF1 = Editor Feedback#1 AR1 = Author Response#1
EF2 = Editor Feedback #2 AR2 = Author Response #2
P = Paper D = Deduction for late work
Final Grade = Total credits available for an assignment

REFERENCES

Alter, C., & Adkins, C. (2001). Improving the writing skills of social work students. *Journal of Social Work Education*, 37(3), 493-501.

Asberg, P., & Nulden, U. (n.d.). Making peer review in large undergraduate courses an option. *The Viktoria Institute and Department of Informatics, School of Economics and Commercial Laws*, Goteborg University, Sweden.

Bagley, C., & Hunter, B. (1992, July). Restructuring, constructivism, and technology: Forging a new relationship. *Educational Technology*, 22-27.

Baker, S., Gersten, R., & Graham, S. (2003). Teaching expressive writing to students with learning disabilities: Research-based applications and examples. *Journal of Learning Disabilities, 36*(2), 109-124.

Bean , J. P. & Bradley, R. K. (1986). Untangling the satisfaction-performance relationship for college students. *The Journal of Higher Education*, 57(4), 393-412.

Bhalerao, A., & Ward, A. (2000). *Towards electronically assisted peer assessment: A case study*. Retrieved July 19, 2003, from Warwick University, Department of Computer Science Web site: http://www.dcs.warwick.ac.uk/~abhir/research/papers/new-alt-j.pdf

Bornstein R. F. (1993). Costs and benefits of reviewer anonymity: A survey of journal editors and manuscript reviewers. *Journal of Social Behavior and Personality, 8*(3), 355-370.

Bostock, S. (2000). *Student peer assessment*. Retrieved August 19, 2003, from Keele University, Learning Technology Web site: http://www.keele.ac.uk/depts/cs/Stephe_Bostock/docs/bostock_peer_assessm.

Boud, D. (1995). *Enhancing Learning Through Self Assessment*. Kogan Page: London.

Boud, D., Cohen, R., & Sampson, J. (1999). Peer learning assessment. *Assessment and Evaluation in Higher Education, 24*, 413-426.

Brock, M. N. (1993). A comparative study of computerized test analysis and peer tutoring as revision aids for ESL writers. *Dissertation Abstracts International, 54*, 912.

Bump, J. (1990). Radical changes in class discussion using networked computers. *Computers and the Humanities, 24*, 49-65.

Butler, R. P. (1973). Effects of signed and unsigned questionnaires for both sensitive and nonsensitive items. *Journal of Applied Psychology, 57*(3), 348-349.

Butler, S. A. (2001). Enhancing student trust through peer assessment in physical education. *Physical Educator, 58*(1), 30-42.

Campbell, K., & Zhao, Y. (1996). Refining knowledge in a virtual community of learners. *Journal of Technology and Teacher Education, 4*(3/4), 263-280.

Campbell, K. S., Mothersbaugh, D. L., Brammer, C., & Taylor, T. (2001). Peer versus self assessment of oral business presentation performance. *Business Communication Quarterly, 64*(3), 23-38.

Candy, P. C., Crebert, G., & O'Leary, J. (1994). *Developing Lifelong Learners through Undergraduate Education*. Canberra: National Board of Employment, Education and Training.

Carson, J. G., & Nelson, G. L. (1996). Chinese students' perceptions of ESL peer response group interaction. *Journal of Second Language Writing, 5*(1), 1-19.

Chaudron, C. (1983). *Evaluating writing: Effects of feedback on revision*. Paper presented at the 17th Annual TESOL Convention, Toronto, Ontario, Canada.

Chisholm, (1991). Introducing students to peer review of writing. *Writing Across the Curriculum, III*(1), 4-19.

Chun, D. (1994). Using computer networking to facilitate the acquisition of interactive competence. *System, 22*(1), 17-31.

The Claremont College Mellon Project Report. (1999, June 26). Electronic writing Assistance for students of the Claremont Colleges. *The Claremont Colleges Writing Centers*. Retrieved July 11, 2003, from: http://thuban.ac.hmc.edu/www.common/writing/centweb/mellon. html

Connolly, T., Jessup, L.M., & Valacich, J. S. (1990). Effects of anonymity and evaluative tone on idea generation in computer-mediated groups. *Management Science, 36*(6), 689-703.

Delbecq, A. L., Van de Ven, A. H., & Gustaffson, D. H. (1975). *Group techniques for program planning*. Glenview, IL: Scott, Foresman.

Dennis, A. R., George, J. F., Jessup, L. M., Nunamaker, J. F., & Vogel, D. R. (1988). Information Technology to support electronic meetings. *MIS Quarterly, 12*(4), 591-624.

Dyrud, M. A. (2001) Group projects and peer review. *Business Communication Quarterly, 64*(4), 106-113.

Eisenberg, M. B., & Ely, D. P. (1993). Plugging into the Net. *ERIC review, 2*(3), 2-10.

Elbow, P. (1973). *Writing without Teachers.* London: Oxford University Press.

Eschenbach, E. A. (2001). Improving technical writing via web-based peer review of final reports. *31st ASEE/IEEE Frontiers in Education Conference*, F3A, 1-5.

Falchilov, N. (1995). Peer feedback marking: developing peer assessment. *Innovations in Education and Training International, 32*(2), 175-187.

Falchikov, N. (1996). Improving learning through critical peer feedback and reflection. *HERDSA conference.* Retrieved September 9, 2003, from: http://www.herdsa.org.au/confs/1996/falchikov.html

Farh, J. L., Cannella, A. A., & Bedeian, A. G. (1991). The impact of purpose on rating quality and user acceptance. *Group and Organization Studies, 16*(4), 367-386.

Ford, B. W. (1973). The effects of peer editing/grading on the grammar-usage and theme-composition ability of college freshmen. *Dissertation Abstracts International, 33*, 6687.

Fuller, C. (1974). Effect of anonymity on return rate and response bias in a mail survey. *Journal of Applied Psychology, 59*(3), 292-296.

Forman, E., & Cazden, C. (1985). Exploring Vygotskian perspectives in education: The cognitive value of peer interaction. In J. Wertsch (Ed.), *Culture, communication and cognition: Vygotskian perspectives* (323-347). New York: Cambridge University Press.

Gehringer, E. F. (2000). Strategies and mechanisms for electronic peer review. *30th ASEE/IEEE Frontiers in Education Conference, October 18-21*, Kansas City, MO, Session F1B-1-7.

Ghorpade, J., & Lackritz, J. R. (2001). Peer evaluation in the classroom: A check for sex and race / ethnicity effects. *Journal of Education for business, 76*(5), 274- 282.

Gordon, R.A., & Stuecher, U. (1992). The effect of anonymity and increased accountability on the linguistic complexity of teaching evaluations. *The Journal of Psychology, 123*(6), 639-649.

Guilford, W. H. (2001). Teaching peer review and the process of scientific writing. *Advances in Physiology Education, 25*(3), 167-175.

Haaga, D. A. (1993). Peer review of term papers in graduate psychology courses. *Teaching of Psychology, 20*(1), 28-32.

Hansen-Strain, L. (1993). Educational implications of group differences in cognitive styles: evidence from pacific cultures. *Pacific Studies,* 16(1), 85-97.

Hartman, K., Neuwirth, C. M., Kiesler, S., Sproull, L., Cochran, C., Palmquist, M., & Zubrow, D. (1991). Patterns of social interaction and learning to write: Some effects of network technologies, *Written Communication, 8,* 79-113.

Harvard's Expository Writing Program. (2002). *Longitudinal Study Highlights Importance of Writing.* Retrieved June 20, 2003, from: http://www.fas.harvard.edu/~expos/index.cgi?section=archive &version=longitudinal

Hiltz, S. R., & Turoff, M. (1978). *The network nation: Human communication via computer.* Reading, MA: Addison-Wesley.

Hiltz, S. R., Johnson, K., & Turoff, M. (1986). Experiments in group-decision making. *Human Communication Research, 13*(2), 225-252.

Jessup, L. M., Connolly, T., & Tansik, D. A. (1990). Toward a theory of automated group work: The deindividuating effects of anonymity. *Small Group Research, 21*(3), 333-347.

Johnson, D., Sutton, P., & Poon, J. (2000). Face-to face vs. CMC: Student communication in a technologically rich learning environment. *ASCILOTE 2000 conference.*

Kalgo, F. (2001). Sex and age trend of field-independent/dependent among secondary school student in Sokoto State. *IFE PsychologIA, 9*(1), 105-114.

Kelm, O. (1996). The application of computer networking in foreign language education: Focusing on principles of second language acquisition. In M. Warsehauer (Ed.). *Telecollaboration in Foreign Language Learning,* Hawaii: Second Language Teaching and Curriculum Center, 19-28.

Kern, R. (1996). Computer-mediated communication: Using e-mail exchanges to explore personal histories in two cultures. In M. Warsehauer (Ed.). *Telecollaboration in Foreign Language Learning*, Hawaii: Second Language Teaching and Curriculum Center, 105-119.

Kerr, N. L., & Bruun, S. E. (1981). Ringelmann revisited: Alternative explanations for the social loafing effect. *Personality and Social Psychology Bulletin, 7*(2), 224-231.

Kerr, P. M., Park, K. H., & Domazlicky, B. R. (1995). Peer grading of essays in a principles of microeconomics course. *Journal of Education for Business*, July/August, 356-361.

King, F. W. (1970). Anonymous versus identifiable questionnaires in drug usage surveys. *American Psychologist, 25*(10), 982-985.

Knoy, T., Lin, S. J., Liu, Z. F., & Yuan, S. M. (2001). Networked peer assessment in writing: Copyediting skills instruction in an ESL technology writing course. *Submitted to ICCE 2001 (Seoul, Korea),* November 11-14, 2001.

Langston, M. D., & Batson, T. W. (1990). The social shifts invited by working collaboratively on computer networks: The ENFI project. In C. Handa (Ed.), *Computers and community: Teaching composition in the twenty-first century,* 140-159. Portsmouth, NH: Boynton/Cook.

Leidner, D. E., & Jarvenpaa, S. L. (1995). The use of information technology to enhance management school education: A theoretical view. *MIS Quarterly, 19*(3), 265-291.

Lin, S. J., Liu, Z. F., Chiu, C. H., & Yuan, S. M. (1999). Peer review: An effective web-learning strategy with the learner as both adapter and reviewer. *IEEE Transactions on Education.*

Lin, S. J., Liu, Z. F., & Yuan, S. M. (2001). Web based peer assessment: Attitude and achievement. 2001 *IEEE.* Retrieve June 28, 2003, from: http://www.ece.msstate.edu/~hagler/May2001/05/Begin.htm

Lindblom-Ylanne, S. & Pihlajamaki, H. (2003). Can a collaborative network environment enhance essay-writing processes? *British Journal of Educational Technology, 34*(1), 17-30.

Liu, E. Z. F., Lin, S. S. J., Chiu, C. H., & Yuan, S. M. (2001). We-based peer review: The learner as both adapter and reviewer. *IEEE Transactions on Education, 44*(3), 246-251.

Liu, E. Z. F. & Yuan, S. M. (2003). A study of students' attitudes toward and desired system requirements of networked peer assessment system. *International Journal of Instruction Media, 30*(4), 349-355.

Liu, J., Pysarchik, D. T., & Taylor, W. W. (2002). Peer review in the classroom. *BioScience, 56*(9), 824-829.

Lou, Y., Abrami, P. C., Spence J. C., Poulsen, C., Chambers, B., & d'Apollonia, S. (1996). Within-class grouping: A meta-analysis. *Review of Educational Research, 66*, 423-458.

Lou, Y., Abrami, P. C., & Spence, J. C. (2000). Effects of within-class grouping on student achievement: An exploratory model. *The Journal of Educational Research, 94*(2), 101-123.

Lou, Y. (2001). Small group and individual learning with technology: A meta-analysis. *Review of Educational Research, 71*(3), 449-521.

Lynch, D. H., & Golan, S. (1992). Peer evaluation of writing in business communication classes. *Journal of Education for Business, 68*(1), 44-48.

Mabrito, M. (1991). Electronic mail as a vehicle for peer response. *Written Communication, 8*(4), 509-532.

MacLeod, L. (1999). Computer-aided peer review of writing. *Business Communication Quarterly, 62*(3), 87-95.

Mangelsdorf, K. (1992). Peer reviews in the ESL composition classroom: What do the students think? *ELT Journal, 46*(3), 275-285.

Manoa Writing Program. *Writing Matters 9 – Online Interaction.* Retrieved June 16, 2003, from: http://mwp01.mwp.hawaii.edu/wm9.htm

McCollister, R. J. (1985). Is anonymity worth protecting? *Evaluation & the Health Professions, 8*(3), 349-355.

McIsaac, C. M. & Sepe, J. F. (1996). Improving the writing of accounting students: A cooperative venture. *Journal of Accounting Education, 14*(4), 515-533.

National Center For Education Statistics (1998). *Writing: State Report for Virginia.* U.S. Department of Education, Office of Educational Research and Improvement, NCES 1999-463.

Newkirk, T. (1984). Directions and misdirection in peer response. *College Composition and Communication, 35*(3), 301-311.

Nilson, L. B. (2003). Improving student peer feedback. *College Teaching, 51*(1), 34-39.

Nowack, K. M. (1993). 360-degree feedback: The whole story. *Training & Development, 47*(1), 69-73.

Patton, M. Q. (2001). *Qualitative Research & Evaluation Methods.* Thousand Oaks: Sage Publications.

Paulus, T. M. (1999). The effect of peer and teacher feedback on student writing. *Journal of Second Language Writing, 8*(3), 265-289.

Pelaez, N. J. (2002). Problem-based writing with peer review improves academic performance in physiology. *Advances in Physiology Education, 26*(3), 174-184.

Price, K. H. (1987). Decision responsibility, task responsibility, identifiability, and social loafing. *Organizational Behavior and Human Decision Processes, 40*, 330-345.

Quible, Z. K. (1997). The efficacy of several writing feedback system. Business *Communication Quarterly, 60(2),* 109-124.

Ramsden, P. (1992). *Learning to teach in higher education.* London, Routledge.

Ransdell, S., & Levy, C. M. (1996). Working memory constraints on writing quality and fluency. In Levy, C. M., & Ransdell, S. (Eds.). *The Science of Writing: Theories, Methods, Individual Differences, and Applications.* Mahwah, N. J.:Erlbaum.

Rawson, S., & Tyree, A. L. (1989). Self and peer assessment in legal education. *Legal Education Review, 1,* 135-137.

Richardson, V. (Ed.). (2001). *Handbook of research on teaching.* American Educational Research Association, Washington, D.C. 4th ed.

Richer, D. L. (1992). The effects of two feedback systems on fist year college students writing proficiency. *Dissertation Abstracts International, 53*(08A), 2722.

Robinson, J. M. (1999). Anonymous peer review for classroom use: Results of a pilot project in a large science unit. *Teaching and Learning Forum 99.*

Robinson, J. M. (1999). Computer assisted peer review. *Computer Assisted Assessment,* Kogan Page, 95-102.

Salkind, N. J. (2000). *Exploring Research.* Library of Congress Cataloging-in-Publication Data. Prentice-Hall, Inc.

Schaffer, J. (1996). Peer response that works. *Journal of Teaching Writing, 15*(1), 81-89.

Schulz, K. H. & Ludlow, D. K. (1996, July). Incorporating group writing instruction in engineering courses. *Journal of Engineering Education*, 227-232.

Shaw, V. N. (2002). Peer review as a motivating device in the training of writing skills for college students. *Journal of College Reading and Learning, 33*(1), 68-77.

Selfe, C. L., & Meyer, P. R. (1991). Testing claims for online conferences, *Written Communication, 8*, 163-193.

Siegel, J., Dubrovsky, V., Kiesler, S., & McGuire, T. W. (1986). Group processes in computer-mediated communication. *Organizational Behavior and Human Decision Processes, 37*, 157-187.

Silva, M. C., Cary A. H. & Thaiss, C. (1999). When students can't write. Nursing and *Health Care Perspectives, 20*(3), 142-148.

Stefani, L. A. (1992). Comparison of collaborative self, peer and tutor assessment in a biochemistry practical. *Biochemical education, 20*(3), 148-161.

Stone, E. F., Spool, M. D., & Rabinowitz, S. (1997). Effects of anonymity and retaliatory potential on student evaluations of faculty performance. *Research in Higher Educaton, 6*, 313-325.

Strever, J., & Newman, K. (1997). Using electronic peer audience and summary writing with ESL students. (English as a second language). *Journal of College Reading and Learning, 28*(1), 24-34.

Tannacito, T. (2001). Teaching professional writing online with electronic peer response. *Kairos, 6*(2), 1-7.

Topping, K. (1998). Peer assessment between students in colleges and universities. *Review of Educational Research, 68*, 294-297.

Tuautmann, N., Carlsen, W., Yalvac, B., Cakir, M., & Kohl, C. (2003, March). *Learning nature of science concepts through online peer review of student research reports.* Presented at the annual meeting of the National Association for Research in Science Teaching, Philadelphia, PA.

Valacich, J., Dennis, A. R., & Nunamaker, J. F. (1992). Group size and anonymity effects on computer-mediated idea generation. *Small Group Research, 23*(1), 49-73.

Vinson, M. N. (1996). The pros and cons of 360-degree feedback: Making it work. *Training & Development, 50*(4), 11-14.

Vygotsky, L. S. (1962). *Thought and language.* Cambridge, M.I.T. Press.

Vygotsky, L. S. (1978). *Mind in society: The development of higher psychological processes.* Cambridge: Harvard University Press

Williams, K., Harkins, S., & Latare, B. (1981). Identifiability as a deterrent to social loafing: Two cheering experiments. *Journal of Personality and Social Psychology, 40*(2), 303-311.

Woodward, R. W., & Sherwood, J. J. (1980). Effects of team development intervention: A field experiment. Journal of Applied Behavioral Science, 16, 211-227.

Zariski, A. (1996). Student peer assessment in tertiary education: Promise, perils and practice. *Teaching and Learning Within and Across Disciplines*, 189-103.

Zhao, Y. (1998). The effects of anonymity on computer-mediated peer review. *International Journal of Educational Telecommunication, 4*(4), 311-345.

Zhu, W. (1995). Effects of training for peer response on students' comments and interaction. *Written Communication, 12*(4), 492-528.

Zimbardo, P. G. (1969). The human Choice: Individuation, reason, and order versus deindividuation, impulse, and chaos. In W. J. Arnold & D. LeVine (Eds.), *Nebraska Symposium on Motivation* (pp. 237-307). Lincoln: University of Nebraska Press.

INDEX

peer review process 2, 4, 6, 8-10,
 13, 17-18, 22, 25, 27-8, 32-3,
 37, 46-7, 79-81, 83-5, 87-9,
 96-8
peer review system viii, 7-9, 15, 22,
 26, 30, 40, 44, 61, 72, 75-7,
 81, 86, 90
perceptions 15, 23, 33, 40, 61,
 66-7, 69, 73, 80, 101-3, 140
performance viii-ix, 3, 6, 8-10,
 17-18, 23, 25, 35, 38, 44, 47,
 52-5, 82-6, 99-101, 139-40,
 145-6
perspectives 2, 4, 15, 70, 87, 97,
 128-9, 141, 146
pilot tested 40, 86, 95
population 11, 35, 37, 86, 94-5, 100
positive comments 63, 67, 69, 88,
 92
posting viii, 75, 78
posttest 3, 14, 38-9, 44, 47, 53-4,
 79, 82-3, 86, 95, 100, 129-30
pretest 14, 38-9, 43, 53-4, 79, 82-3,
 94-5, 100, 126, 129

Q

qualitative data 30, 50, 61, 85, 87,
 91-2, 103
qualitative findings 87, 93
quantitative data 80
quantitative findings 61, 85, 87
quasi-experimental design ix, 8, 35,
 47, 50, 82, 103
questionnaire 3, 10, 15, 24-5, 39-
 41, 44-5, 48, 50, 52, 56, 61,
 85-7, 95, 100, 111, 129-30

R

random-rotating 46, 96

reactions 14, 69, 74, 89, 98
recommendations 82, 97, 99
relationship 5, 15, 20, 47, 53, 89,
 92, 94, 100-1, 139
reliable/reliability 4, 5, 6, 20, 22, 26,
 33, 35, 38, 39, 42, 95
research design 10, 33, 35, 40, 82,
 89
research hypotheses 35, 86
respond 85, 131
response rate 45
responses 3, 9, 13, 16, 24-5, 28, 31,
 40, 45, 48-50, 61-78, 87-90,
 92, 95, 111, 125-6
responsible/responsibility viii, 4,
 10, 12, 18, 44, 62, 67, 76, 88,
 91, 98, 111, 131, 145
reviewers/reviewees 5, 6, 7, 10, 15,
 16, 21, 22, 23, 24, 25, 26, 27,
 28, 29, 30, 32, 42, 45, 46, 59,
 62, 63, 69, 73, 76, 84, 88, 96,
 98, 102, 139
revise/revision 12, 13, 14, 15, 32,
 42, 46, 84, 88, 98, 102, 131,
 134, 139, 140

S

sample 10-11, 35, 37-8, 50-1, 86,
 94-5, 98-9, 126, 129
satisfaction with the course 33, 35,
 39-40, 48, 57-8, 78-9, 85, 88,
 90, 113
satisfactory 62, 66, 75
share/sharing 2, 3, 5, 21, 43, 65, 88,
 91, 92, 125
significant difference 14-15, 57, 60,
 85, 88
social constructivism 2, 17, 88
social interaction 2, 17, 142

Epilogue

If my memory serves me correctly, I was only a sophomore in high school when my mother started her research for this book. Years flew by, and now, as a doctoral candidate myself, I write this epilog with great appreciation, both for her hard work and for her motherly love.

This book has special importance to me, not just because my mother wrote it, but also because I share a great deal of personal connection with her work. Back in 2003, when my mother first started working on her doctoral dissertation, I couldn't help but thinking we must be an extremely strange family—we were a family full of "students". My father was concluding his doctoral studies, my mother was embarking on her doctoral research, and I, a clueless high school student, struggled with adjustment to my new life here in the United States. Needless to say, with everyone in the family being full-time students, we were constantly under economic strain. Despite all the hardships we were facing, there was a great sense of camaraderie between us, with everyone cramming for those exams we never studied for, or rushing to finish papers that were due the next day.

My mother is a hardworking one in the family, not that any one of us is particularly unmotivated, but my mother has always been the one who spends the longest time studying. We always joke about her "straight-A student career" even in a foreign country. My mother is also the backbone of our family, performing all the household duties in addition to her study. No words can describe my appreciation for what she has done for the family. Her do-no-evil personality and her work ethic are inspirations to my own academic career, and she continues to help guide me through difficulties in my life.

In closing, through this epilog, I hope the readers will not simply appreciate the academic merit of this work, but also see the human element behind its creation.

Keren Wang

Philadelphia, Summer 2011

ABOUT THE AUTHOR

Dr. Ruiling Lu obtained her Ph.D. degree in education in 2005 from Old Dominion University in the United States. Her master's degree is in English Linguistics & Literature, and her bachelor's degree is in English language.

After earning her Ph.D. degree, Dr. Lu was employed by Old Dominion University Research Foundation as a postdoctoral researcher, doing program evaluation for a federally funded program—WHRO-NCLB. Before coming to the United States in 2000, Dr. Lu was an assistant professor at a Chinese teacher education institute, involved in training in-service English teachers. Prior to that, she taught English at a Chinese high school for seven years. Having been a teacher, professor, and researcher for many years, Dr. Lu has sufficient experience in English language instruction, program evaluation, and bilingual education. Currently she is an associate professor at Taiyuan Normal University.